MASTERING
UNDERWATER
PHOTOGRAPHY

Also by Carl Roessler

The Underwater Wilderness

MASTERING UNDERWATER PHOTOGRAPHY

CARL ROESSLER

FOREWORD BY PAUL TZIMOULIS

WILLIAM MORROW AND COMPANY
New York | 1984

Copyright © 1984 Carl Roessler
All rights reserved. No part of this book may be reproduced or utilized in any form or by any means, electronic or mechanical, including photocopying, recording or by any information storage and retrieval system, without permission in writing from the Publisher. Inquiries should be addressed to William Morrow and Company, Inc., 105 Madison Avenue, New York, N.Y. 10016. Printed in the United States of America.

1 2 3 4 5 6 7 8 9 10

Library of Congress Cataloging in Publication Data
Roessler, Carl, 1933- Mastering underwater photography.
Includes index. 1. Photography, Submarine. I. Title.
TR800.R59 1984 778.7'3 84-6541
ISBN 0-688-03881-6 ISBN 0-688-03882-4 (pbk.)

To Jessica—
wife, best friend, and the
world's finest undersea model

CONTENTS

FOREWORD

For a quarter-century, *Skin Diver* magazine has been the primary market for the world's leading underwater photographers to show their best work. Stories on travel and marine life are naturally a principal feature of *Skin Diver;* indeed, for many years our "Fish of the Month" has been one of our most popular offerings.

It was through the "Fish of the Month" that Carl Roessler first appeared in the pages of *Skin Diver.* Here, in the most competitive arena for the world's best fish photographers, Roessler rocketed to preeminence. In fact, over the past decade Carl Roessler has reigned as the unquestioned master of fish portraiture.

Nor was this his only strength. During these past years Carl has traveled the world as president of the world's foremost dive-travel company, See & Sea Travel, Inc. of San Francisco. He has written brilliantly illustrated travel articles on areas such as Australia, the Galápagos, the Cayman Islands, Belize, the New Hebrides (Vanuatu), Fiji, and many others. His 1977 masterpiece, *The Underwater Wilderness* (Chanticleer Press), is to this day considered one of the finest underwater books ever produced.

Roessler's expertise is thus wide ranging. Whether the subject is fish portraiture, reef scenes, sharks, or his beautiful model and wife,

Jessica, his tips and techniques are invaluable to aspiring underwater photographers.

In this concise volume, Carl Roessler shares with you the secrets of his success. They are worth reading—and rereading. This is a most valuable addition to any photographer's library.

Paul Tzimoulis
Publisher
Skin Diver Magazine

INTRODUCTION

A mere twenty years ago, underwater photography was the province of a select few adventurous pioneers. These hardy souls knew each other, envied each other, and competed fiercely for the few, insignificant magazine or book pages devoted to underwater subjects.

At parties and other social gatherings in those halcyon days, the mere mention of one's underwater photography adventures was sure to fall on receptive ears simply because the listeners had never before talked to an underwater photographer. These audiences hung raptly on tales of sharks, snakes, and other marine creatures usually word-painted in lurid, even savage, terms. The early photographers were shameless sensationalists, and some early films and books are good for a laugh today with their tales of killer manta rays and vicious giant clams (both, in truth, the most gentle and unoffensive of reef citizens).

How times have changed. Anyone trying to regale a modern audience with those overblown sagas would have half the crowd properly objecting on grounds of conservation. The other half of the erstwhile listeners would be interrupting to regale you with tales of *their* latest diving efforts.

Today, literally thousands of people have taken formal underwater

photography courses, and hundreds of thousands have tried taking pictures in the sea. It is estimated that a quarter-million new divers enter the sport each year, and some 400,000 actually travel to the tropics for their diving. Of these, half or more are eager to take pictures to express to their family and friends what they have experienced in the sea.

Usually by trial and error, these many thousands of aspiring photographers discover that there are certain characteristics of the underwater environment that severely impact photography; moreover, there are a wide variety of subjects that require totally different photographic techniques to capture on film.

Those who have some understanding of photography and have perhaps tried taking underwater pictures on their own are often at a loss as to how to improve their skills. They have *knowledge,* an understanding of f-stops and lens focal lengths and what equipment to buy, but not *technique,* how to use that knowledge to improve their product, the pictures. Thus, when they subsequently take a diving vacation, they sometimes find themselves unable to adapt to new conditions and new subjects.

In my dual role at my company, See & Sea Travel of San Francisco, I'm a travel consultant and also a dive guide for thousands of divers. I've seen many a graduate of reputable photography courses nonplussed by changes in water clarity, sunlight and cloud conditions, and especially by the behavior of marine animals they are seeing for the first time. Let's face it, if you can't get good pictures, knowing what f-stops are has limited value indeed.

This book is intended to take up where trial and error and even beginner courses end. It is intended to discuss *techniques* you can use in approaching certain common marine subjects and *effects* you can achieve in underwater photography using other divers or the underwater scenery itself. The application of its suggestions and advice should elicit an "of course!" reaction, since most good underwater technique is applied common sense, after all.

I can admit to having made all the mistakes that have ever humbled a novice, and more grandiose ones, as well. It's the price I paid to learn in the years before organized instruction when the few underwater photographers jealously guarded their secrets.

Another important facet of this book is that its techniques are applicable *anywhere*—in a quarry, in Long Island Sound, off the California coast, or anywhere in the world. Good technique is good technique. It will stand you in good stead wherever in the world *you* dive.

Now, I certainly don't have any monopoly on good technique. What I do have to share with you is a long career taking pictures in underwater locales around the world. In my career in the sea I've shot well over 200,000 pictures. Many of these have appeared in a wide variety of magazines and textbooks. Along the way I've acquired what some would call secrets but what I think of as experience and technique.

I'd like to share that experience with you as I do with my many clients on See & Sea dive trips all over the world. By this sharing I hope to save you from the countless common errors that may occur in underwater photography. You could learn all of it by making your own mistakes and learning from them, as I did and as many new photographers still do.

Why should you reinvent the wheel, though, if I can tell you from experience how it works?

ONE

CAUTION:
MEDIUM AT WORK

The first and most obvious things to learn in underwater photography are some characteristics of this very different medium itself. The water in which you dive affects you, your equipment, and your subject simultaneously, in ways that may be totally foreign to your picture-taking on land. Indeed, I often think of the underwater environment as a whole new world for photography.

An experienced underwater photographer enters the water, looks around, and immediately begins drawing conclusions about what effect the water will have on his or her photographs. As you gain experience, you will make the same assessments instinctively.

CLARITY

First, judge the clarity. Water—even beautiful tropical water—is not really clear. The clarity we see in an underwater picture is, for example, quite poor when compared to visibility above water. Microscopic animals called plankton, grains of stirred-up sand, and coral debris from waves impacting the reef are ever-present in tropical water and so will be visible to some degree in almost all underwater pictures.

Water is opaque, and its relative clarity (or rather, lack of true clarity) will directly affect your pictures in two ways:

4

1. The more particulate matter there is in the water, the less sunlight can penetrate to your subject. This is particularly true as you go deeper and the column of particle-filled water the sunlight must traverse grows longer. Those of you who have been fifty or one hundred feet deep in murky green water know it can be awfully dark down there. Indeed, that is one reason divers carry various types of hand-lights and strobe lights, even in the tropics. Hand-lights may be necessary to even see your potential subjects as you go deeper. Certainly in deeper waters, distinguishing colors will require a hand-held flashlight.

 For your photographs, the absence of sunlight is even more serious. Commonly used film emulsions are not nearly as sensitive as your eye. For this reason flashbulbs (now largely obsolete) and strobe lights provide sudden, intense light to expose an image on the film.

2. The second impact of visibility is the light emanating from those hand-lights and strobe lights. The murkier the water, the more of your strobe light will bounce and scatter off the intervening particles and thus never reach the subject. This phenomenon of strobe light being scattered by particulate matter is called *scattering*, for obvious reasons.

As a perfect example of scattering, I recall taking a dive group to the Galápagos islands after I spent several years diving in the clear waters of the Caribbean and South Pacific. The water of the Galápagos comes northward from Antarctica via the Humboldt Current, bathing the coasts of Chile, Peru, and Ecuador with cold, plankton-filled, green-tinted water. Visibility and water color are much like those of the waters off the east and west coasts of the United States. After my years of Caribbean photography I had my distances and f-stop settings pretty well standardized, and I proceeded to use them on the fabled dive subjects of Darwin's legendary Enchanted Islands.

When I returned home and had the pictures developed, I found a horrifying pattern: The photos taken at very short distances were fine, but those from two feet or more away were often underexposed. The answer, of course, was that when the strobe light was very close to the subject, the intense light blasted through the short column of

particle-filled water; but as the water column grew longer, the light scattered off the particles and only part of it reached the subjects.

I mention this in detail because no one simple solution, such as opening the lens by one f-stop for every shot, would have entirely solved the problem. On my next trip to the Galápagos islands I achieved satisfactory exposures by using the Caribbean f-stop settings for distances less than two feet, but to compensate for the poorer visibility of this water, I opened the lens an extra f-stop for distances of two feet or more.

Another related symptom in these water conditions is exemplified by the pictures you take that look as if they were shot in a snowstorm. This is called *backscattering.* The "snow" is the intense light from the strobe illuminating particles in much the same way the sun illuminates the full moon in the night sky. Since it is impossible to remove the particles from the water, you might find that it helps to take another clue from the moon. By holding the strobe well off to one side, you can turn the "full moon" effect into that of a "half moon" and immediately improve the pictures even in particle-filled water. That is why you will see divers with their strobe lights mounted on metal arms up to four feet long. Remember, however, that even though this "half moon" lighting reduces backscattering, as you move that light source farther from the subject you will lose the brilliance and intensity of color you want in the subject. Like many techniques in underwater photography this involves trade-offs you must balance to your personal taste.

Some of you who dive cold green water may know all of this well. You, however, could be subject to an opposite danger—overexposure —when you subsequently dive in crystal clear water.

A few years ago I took my first trip to the Maldive Islands, 400 miles west of Sri Lanka (formerly Ceylon) off the tip of the Indian subcontinent. The waters lapping the Maldives are those of the delightfully clear Indian Ocean; moreover, most of the fine coral reefs are quite shallow. After the trip I came home with a portion of my shallow-water pictures *over*exposed, far too bright. The combination of my normal strobe light with the high level of sunlight penetrating to the shallow reef made my accustomed settings wrong again. Photogra-

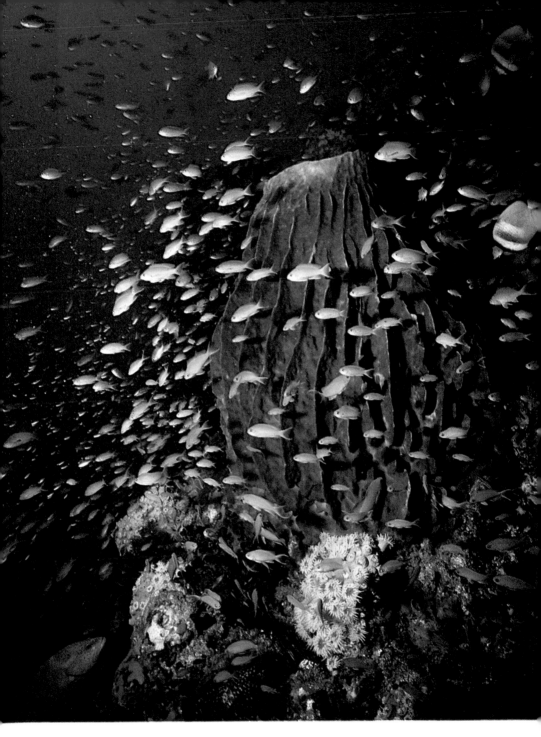

Even in murky, plankton-filled water, a wide-angle lens and strobe may find a rich tapestry of marine life (Batangas Province, Philippines).

phers call the background level of light *ambient light*. What happens in high levels of ambient light is that your camera shutter opens and the ambient light immediately begins exposing an image on your film. Then your strobe fires with an intense burst of light. The combination of the ambient exposure *plus* the strobe exposure causes a double (and very bright) exposure.

On subsequent trips to the clear, sun-filled waters of the Maldives I improved my results by:

1. Getting closer to the subject. The higher f-stops used at close distances reduced the effect of the ambient sunlight.
2. Going a bit deeper where the sunlight was greatly reduced from having passed through more water; the strobe then became the primary light source.
3. Shading some small subjects with my hand. We'll be discussing the use of lights in more detail in Chapter 4; I've mentioned them here only in relation to water effects. Later we'll see how powerful they can be in producing what you desire in an underwater photograph.

THE BLUE EFFECT

The second great effect water has on your photography is the attenuation of certain frequencies of sunlight. As you dive down through clear tropical seawater, things gradually assume a monotone blue color. The sunlight's refraction at the red end of the spectrum is noticeable even a few feet beneath the surface; at depths of fifty feet or more, you dive in an intensely and exclusively blue world where even the most spectacular colors are almost indistinguishable.

In some cases (on page 19 for example) the dominance of the blue color can be used for spectacular effects. Sometimes the brilliant blue background can intensify the impact of a reef scene or model, as it does in the photo on page 34. The most extreme use of the ocean's blue is in the pure silhouette of the photograph on page 11 where the entire picture is in shades of blue, and the impact is in the graphic design or composition of the photograph. A silhouette-type of picture is equally effective in black-and-white.

Portraits of reef creatures, on the other hand, would be unexciting at best if they were all black-and-white photographs with a deep blue

tint. In passing, it should be mentioned that early underwater photos (and particularly movies) were precisely like that and today are often visually boring to view.

To overcome the blue effect, photographers will utilize hand-lights, photographic strobe lights, or powerful cine lights (for movies or videotape). When these lights strike corals or fish, they restore the complete spectrum of color and enable the camera to record the astonishingly vibrant hues in many of the reef inhabitants. The actual use of such lights will be discussed further in Chapter 4, but for now, remember that without them, *all* underwater pictures except for those taken in brilliant shallow water would be blue, blue, blue.

_____ A MOVABLE FEAST _____

The third and most critical effect of water on underwater photography is the motion it imparts to you and your subject. An obvious example is to imagine yourself trying to photograph moving fish in shallow water with huge wave surges sweeping both you and the fish back and forth. That may sound extreme but only in degree. Water is always in motion (whether wave surge or current), and its movement simultaneously affects you, your subjects, and the background scenery in various ways.

These effects move you and your subject about physically. But also, the behavior and even the appearance of some undersea animals is changed by water motion. As an example, a fish or diver/model portrait on a beautiful reef with exotically colored soft corals can be a marvel; soft corals, however, tend to deflate when the water is dead still. Ironically, that means that when the still water makes it easiest for you to arrange your subject matter, the colorful part of that subject matter may be at its visual worst. Conversely, when a current is moving and the soft corals are erect and vibrantly colored, you might have to swim very hard to bring your composition into any semblance of order.

The water is also affecting you at all times because of your buoyancy. Your easiest swimming occurs when you are neutrally buoyant at any depth; that is, neither too heavy nor too light. To achieve good photographs, practice until you have mastery of your buoyancy. This is a must; otherwise, you could land on your intended subject like a

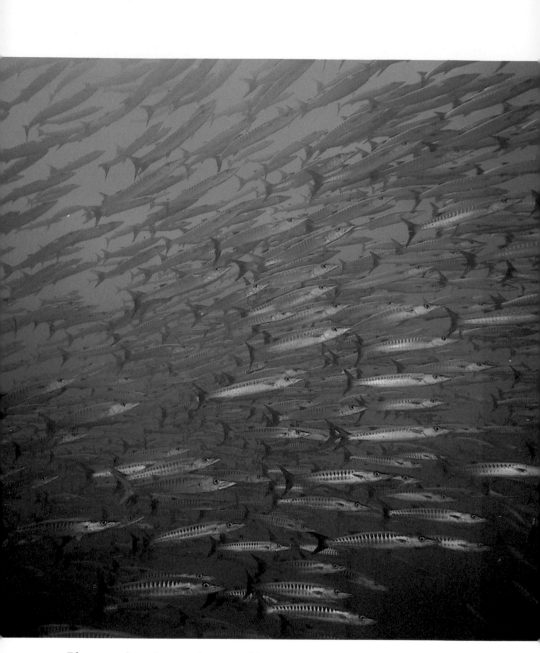

Photographing large subjects in blue water may require combining strobe light with ambient light (above: a school of barracuda, Palau, Micronesia) or utilizing the sun to silhouette your target (right: Jessica Roessler is dwarfed by the mast of the Fujikawa Maru, *Truk Lagoon, Micronesia).*

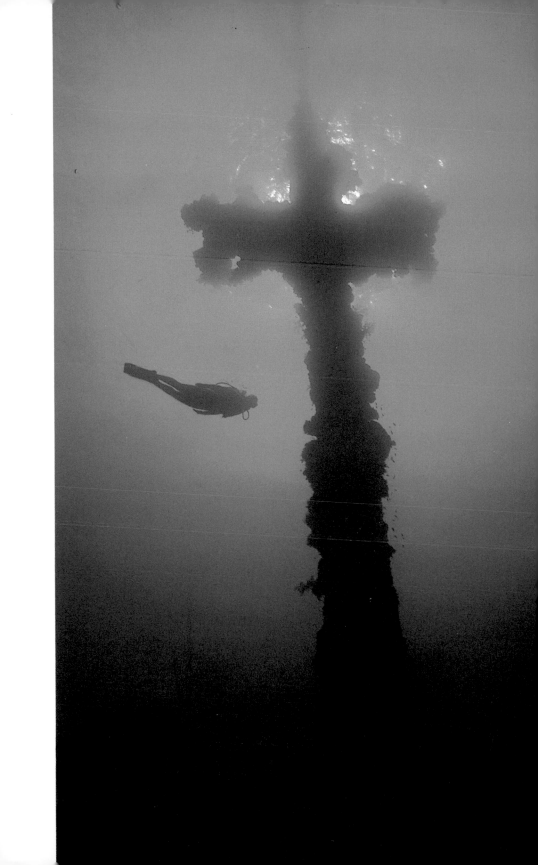

bomb from the sky, or float away in the middle of the shot.

Another frequently underestimated effect of water is that of cold or fatigue on the photographer. I have lain motionless in wait for a fish until my teeth chattered, and have discovered that being cold can disturb my concentration badly. Since timing is everything in fish photography, anything that affects your reaction time and timing will probably lose you the picture you are after. In extreme cold you may even impair your coordination, but sport photographers seldom expose themselves to conditions that severe.

Even worse are the consequences of fatigue. Photographers often make gross errors when they have undertaken long swims or have had to work against current or surge. If you are lucky you'll only ruin a photo; I have known divers who actually flooded their equipment because of using it or assembling it when fatigued.

One of the most insidious types of exhaustion is that of jet lag. Divers who fly long distances should avoid assembling their equipment when jet-lagged; it's a sure way to turn a nice camera into an aquarium.

When you take up underwater photography, you are taking pictures in a new world. Recognizing and responding properly to the environmental effects of that world can be crucial to the images you eventually see on your film.

TWO

A WORLD OF VARIETY:
CAMERAS AND OTHER EQUIPMENT

Over the years a broad range of cameras and lenses has evolved that allows the underwater photographer to capture the variety of undersea subjects. Properly treating the enormous selection of equipment would take a compendium far beyond the scope of this book; worse, the reader would be at sea in an ocean of detail.

However, the general principles discussed in subsequent chapters will lead you to particular techniques and specific types of equipment appropriate for several major classes of subject matter.

CAMERAS

There are basically two types of cameras that are used underwater: cameras specifically designed for underwater use; and regular cameras for which metal or plastic waterproof housings have been designed.

Range-finder Cameras

The most widely used camera designed specifically for underwater use is the 35mm Nikonos by Nikon, for which an impressive catalog of accessories has evolved. Other manufacturers have recently introduced other models, some for the smaller 110 size film. I personally believe those 110 cameras are inadequate beyond your very first few

pictures because of their extremely small film image. I recommend the 35mm format as embodied in the Nikonos.

The Nikonos is a *range-finder camera;* that is, when you look through its eyepiece, you are *not* seeing exactly what the lens is seeing but rather the view through a small window adjacent to the lens. Range-finder cameras are simpler and less expensive to manufacture, and consequently they cost less to buy and are easier to operate. For photography at a distance of several feet or more, the slight difference in view between viewfinder and lens simply does not affect the result. As the subject gets closer to the camera and lens, however, the difference in view field, called *parallax,* can result in such disasters as leaving your diver/model's head out of the picture.

When photographing large subjects such as divers, sharks, whales, and reef tops with a range-finder camera, the solution is quite simple. Use a wide-angle lens. It will allow you to make a slight parallax error without ruining the photograph; after all, with a wide-angle lens the subject is usually in the center of your photograph, and the edges are either empty or unimportant to the overall picture.

For portraits of single reef animals or smaller areas much closer to the lens, however, the parallax problem demands a more precise solution. When taking such photographs with a range-finder camera, you should use an optical sighting device known as a *framer.* This is a metal picture frame that sticks out in front of the camera and shows you approximately what the lens sees. Lenses in the 15 to 28mm range of focal lengths can be armed with a similar sighting device, either an optical "scope" or a little square plastic frame mounted atop the camera.

Thousands of photographers use such framers; they work beautifully with stationary subjects. They are, unfortunately, less successful with fish because the intrusion of the framer can frighten off the quarry before the photographer is ready. Also, different-sized subjects require different framers, so that by attaching a particular lens and framer you commit yourself to one specific subject size before entering the water. You can be sure that if you go in with a framer of a certain size, the finest subjects you encounter will be of some other size.

One way to avoid the problems inherent in range-finder cameras

would be to use a single-lens-reflex or through-the-lens camera. In this type of camera a series of mirrors shows you exactly what the lens is seeing until the moment you take the picture. Then the main mirror is instantaneously retracted, the shutter opens to expose the film, and the mirror drops back into place. Thus, you can focus directly upon the subject, a major advantage in composition. Unfortunately, no single-lens-reflex, Nikonos-type camera has yet been put on the market, leaving a niche for what are called *housed cameras.*

A housed single-lens-reflex camera allows you to compose your picture as the lens sees it—a major advantage (moorish idol, ZANCLUS CANESCENS, Coral Sea, Australia).

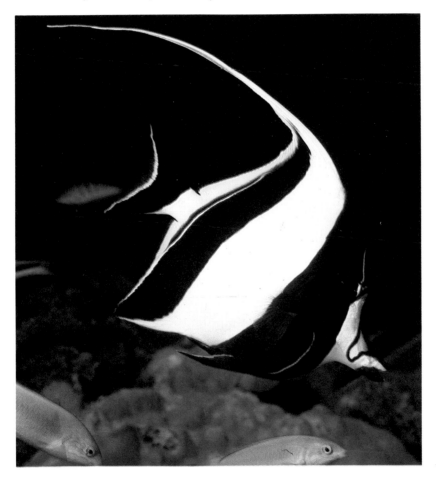

Housed Cameras

These are regular single-lens-reflex cameras installed in elaborate boxes of metal and plastic. Gears and levers enable the diver to manipulate the sealed camera's controls from outside the box. Because of the clearances required for the operating mechanisms, these housings are several times the size of the camera and often weigh ten pounds or more by themselves. With the camera installed and external strobe lights attached, they can be a real handful, even two.

The overwhelming advantage of housed single-lens-reflex cameras is that you see exactly what will be in the photograph when you pull the trigger. I have often discovered a stray wisp of coral or a bit of debris in the view field, so was able to hold off pulling the trigger until the composition was precisely what I wanted. The second advantage of using housed cameras when photographing small subjects or fish is that there is no intrusive framer to disturb or scare off the subject.

The disadvantages of housings are easy to imagine. They are bulky to travel with on airplanes and heavy to lug around in the water. They are also very expensive, ranging up to $1,000 and beyond, not including any camera. A third disadvantage is rather insidious. Any housing is a box full of sealed holes waiting to leak. My main housing, as an example, has sixteen openings sealed with rubber O-rings. Sooner or later a grain of sand or a bit of hair caught in one of the seals or a break in the rubber under stress will let the ocean in.

Cameras and lenses designed for topside use are destroyed when exposed to even small amounts of seawater. Be meticulous when cleaning and greasing O-rings, and also look in through the plastic ports for signs of water throughout the dive. When in doubt, first test the housing by hanging it in water *before* installing the camera in it (you will need a couple of lead weights because of the housing's buoyancy). This precaution may just save your camera.

LENSES

Lenses used underwater are highly varied but can be grouped into two general categories: lenses for large subjects such as reef scenes, divers, sharks, rays, and whales; and those for small subjects such as reef fish, coral polyps, and worms.

Lenses for Larger Subjects

These lenses are called *wide-angle* and range in focal length from 35mm down to 15mm or even less. Popular underwater lenses have been produced in 15, 17, 19, 20, 21, 24, 28, and 35mm lengths. The extreme wide-angles (15mm to 21mm) tend to be more expensive and involve more sophisticated optics. Each focal length has partisans who find it just right for them. I personally favor 15mm and 24mm lenses for wide-angle shooting.

A wide-angle lens enables a 35mm-sized film image to "see" a wider angle of view. A common example on land would be to stand right in front of Paris's Notre Dame cathedral and try to capture the entire edifice. A super-wide lens such as a 15mm would do it, but with a 35mm lens you'd have to move back a block or more.

The opacity of water is a powerful incentive for using wide-angle lenses; the farther back you move, the more particle-filled water you see. When photographing a diver (or whale or whatever), you would like to get very close for water clarity but still get all of the subject in the picture. The wide-angle lens accomplishes this beautifully.

Portrait or Telephoto Lenses and Framers

These lenses do precisely the opposite of what wide-angle lenses do. Like a telescope they take a small field of view and magnify it. Popular lenses in this category are of 80, 105, and 135mm focal lengths.

The obvious benefit of a telephoto lens is that it enables you to photograph a subject that won't let you get really close. The problem with lenses of 80mm or longer is that you need exceptionally clear water, because you are shooting through a particle-filled water column that can be several feet long. However, in later chapters you'll learn that there are many ways to maximize the advantages and minimize the disadvantages of these lenses.

_____ ANCILLARY PHOTOGRAPHIC EQUIPMENT _____

There is a staggering variety of other equipment that ranges from the necessary to the totally worthless.

Strobe lights vary greatly but can be summarized as intense light sources synchronized with your camera shutter. These strobes usually

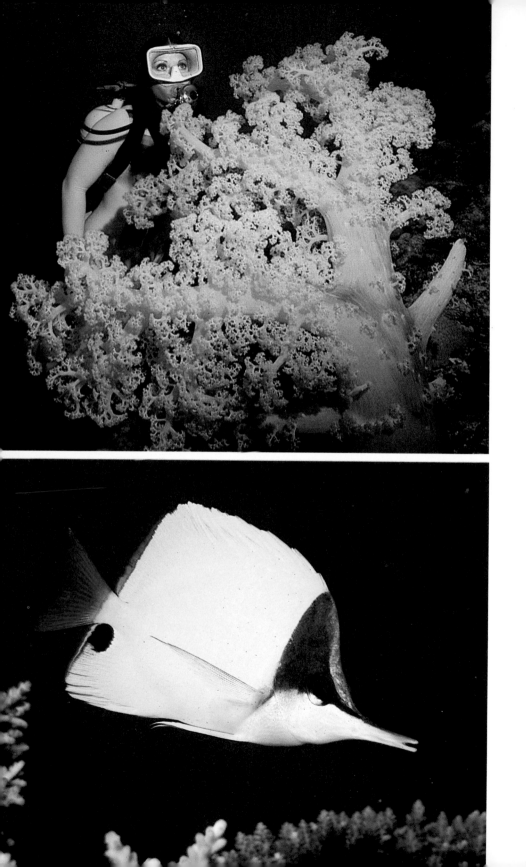

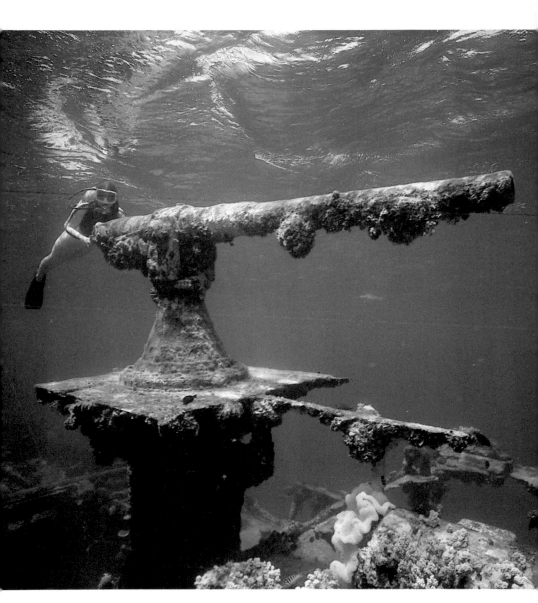

Different lenses for different subjects: (top left) A 15mm lens captures Jessica with a large soft coral in Australia's Coral Sea; (above) a 15mm lens also is excellent for larger subjects in ambient light, such as this gun in Truk Lagoon, Micronesia. For smaller subjects, such as this long-snout butterfly fish in Astrolabe Reef, Fiji (bottom left), a 55mm lens excels.

are connected by *cords* to the camera or housing; the cords transmit electrical pulses to fire the strobe. Frequently, strobes are mounted on metal *arms* so you can carry a camera-strobe combination with one hand. I've mentioned *framers* and optical scopes earlier.

You can also use an underwater *light meter* to directly read the f-stop for a shallow-water sunlit scene. However, light meters are not particularly helpful in low-light situations as they become inaccurate at the extremes of their ranges.

There are wrenches, screwdrivers and other tools, spare O-rings, O-ring grease, and an endless litany of other necessities. When I leave for a dive trip, I may have two hundred pounds of gear with me. Backup cameras, backup strobes, backup arms, backup cords—I think you see the pattern.

Before leaving ancillary equipment, I should mention the film I use for color slides. This involves more personal preference, for some photographers prefer slow (for example, ASA 25) film for better light saturation, while others like fast (ASA 200 or more) for low-light conditions. I compromise, using an ASA 64 film that produces intense color images in strong light and is pretty good even in deeper water. I do not jump around from film to film but use the same type at all times for consistency.

OTHER EQUIPMENT

We should pause for a moment here to consider some equipment that you wouldn't think of as "photography equipment" but that can nonetheless enhance or impair your photography.

Mask

A comfortable mask with a clear field of view is a must. It should have a tempered-glass port (or ports), and you should use an antifog compound or an expectorant to be sure that the glass plate stays clear. I frequently stop before approaching a subject to let water into my mask to rinse the plate so my vision is unimpaired. The fit of the mask is also important; a poorly fitting one can cause a variety of distractions, from annoying leaks to painful headaches. For this reason, rental masks at resorts should be avoided in favor of your own.

Swim Fins

Seem unimportant to photography? Try getting into position in front of a manta ray or shark when you are wearing small or overly pliant blades. Good, big, stiff-bladed fins are hard to get used to, but when you need them you'll *really* need them.

Buoyancy Compensator

One of the great secret weapons of top underwater photographers is a mastery of buoyancy. You should wear a top-quality compensator, with as little air in its bag as possible. That requires that you wear the minimum amount of lead weights you absolutely need to descend. Divers who carry several unnecessary pounds of lead and compensate with a balloon of unnecessary air in their compensator make their diving much harder because this combination places them in a vertical rather than in the proper horizontal orientation. It is *very* hard to swim forward in this vertical position. It's also totally unnecessary to try. In the next chapter, I'll explain when this becomes critical.

Wet Suit

A proper wet suit for the water temperature assures comfort, and comfort enhances concentration. The thickness and insulating quality of the suit is important—old suits, for example, get leathery as their embedded air cells collapse, and thus lose their insulating quality. Fit is also crucial. I've seen divers whose hoods were so tight that their circulation was choked off.

Gloves

Every diver seems to have a personal preference about gloves. In very cold water you may be forced to wear thick rubber mittens. In tropical waters plain dishwashing gloves such as Bluettes are hardy enough to survive handling sharp corals but thin enough to still give you complete flexibility for handling the camera controls.

The selection of all camera and diving equipment involves personal choices. What works for me may not be comfortable for you. Yet you must start somewhere, and in this chapter I hope I have given you some considerations you might use as starting points.

THREE

A KEY ELEMENT:
YOUR SWIMMING AND DIVING SKILLS

Photographers always wonder how they can improve their photos. Invariably they think in terms of newer, more complex, more expensive cameras or housings. Yet, the fundamental way to improve your pictures is to improve your diving skills and thereby your physical approach to your subjects.

BUOYANCY

One of the diving skills that must be mastered was mentioned at the conclusion of the previous chapter. Top underwater photographers have an unconscious control of buoyancy. By not being overweighted with lead and overbuoyed by excess air in their buoyancy compensator, they reduce their exertion and present a smoother profile to the water. This avoids an enormous inefficiency and saves them an energy expenditure that could lead both to exhaustion and to frightening off their subjects with their thrashing exertions.

I called this mastery unconscious because, with enough practice, you never think about it, you simply make the proper adjustments automatically. After all, as you prowl the reef, you want to concentrate on your photo subjects. Thinking about what to do with your diving equipment would simply be a distraction.

PHOTOGRAPHY AS HUNTING

You must also be skillful enough to control your movements so you can approach your subjects without frightening them off. Underwater photography, particularly of fish or large marine animals, closely resembles the sport of spearfishing. The process of stalking your subject is almost identical, the wariness of the subject precisely the same. In fact, wildlife photography in general *is* hunting, except for the effect that follows from pulling the trigger. The hunter imposes death while the photographer confers a kind of expanded life; not only does the subject continue to live but also that moment of its life achieves a life of its own.

In my opinion, it is easier to train a skilled spearfisher to take pictures than to teach a studio photographer to stalk wary animals, because the skilled stalker will approach the subject and get closer than the clumsy diver.

However, this oversimplification ignores one important element that I should mention immediately. Even the best stalker must have a photographer's "eye." Any photographer needs to recognize the elements of composition and pull the trigger only when those elements are satisfied. It does no good to get close to a fish only to photograph it at a jarring angle.

This wary female Indian lobster will instantly withdraw if your approach is at all clumsy or threatening (Cayman Islands, Caribbean).

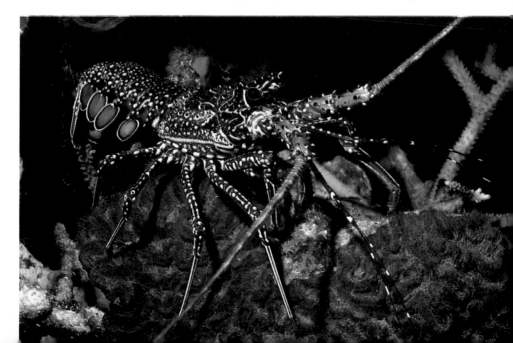

___ APPROACHING THE WARY REEF COMMUNITY ___

Consider this situation: You've just entered the water, and you're swimming downward from the surface. To the fish that see you coming you are a terrifying sight—you're as big as a shark, but much noisier. Don't be surprised if you see the reef fish scurrying for shelter as you descend.

Since you must descend somewhere, the disturbance you create is hard to avoid. Once down at reef level, though, make it a practice to pause, slow your breathing, and survey the reef for likely subjects. This accomplishes two things. First, you cease your threatening descent so the animals can gradually resume their normal activities. Second, if there are unusual or rare animals present, you may now detect them and plan your approach.

The finesse of that approach may not matter in the case of a coral or other rooted animal, but swimming creatures may flee. For those subjects, a different technique is demanded. I think of it as "low, slow, and silent."

Envision it this way. What frightens a small fish is your size, your noisiness (those exhalations sound like thunder!), and your unknown speed of attack. Underwater predators such as sharks or barracuda swim above the reef, then make lightninglike rushes to attack their prey. If you swim above the reef, all the fish will be watching you to gauge the moment and speed of your potential attack.

To illustrate this heightened awareness on the part of the smaller fish, I recall an afternoon dive on a quiet reef in the Maldives. I was in the process of photographing a school of snappers hovering above the coral when suddenly there was a whipcrack of sound and a huge jack rocketed in, snatched a snapper, and zoomed away. The fish were so jittery from that moment on that taking portraits became an impossibility. Your own incautious or unskilled approach could have much the same effect.

The answer is to act not like a jack or shark or barracuda, but instead like another reef creature—like one of your subjects. You can do this by moving slowly, hand-over-hand, keeping your body low to the coral. *Be careful, though!* When you use the coral for a handhold, select the dead pieces or you may harm thousands of living animals.

You can recognize the dead corals by their skeletal-white color or by the scrub algae growing on them.

Your prey should hardly react to your approach until you are mere inches away. You'll find, as I have, that if you sit motionless and silent on a reef, after a few seconds the animals seem to forget your presence or treat you as if you were a coral head. On occasion you may interrupt an approach this way in order to let the animals resume their feeding. Like land animals, reef creatures seem most tolerant while feeding. Now and then you can get very close to a school of fish that are busy eating.

Parenthetically, you will have trouble working low to the coral if you have all kinds of consoles, gauges, and hoses hanging down to catch on the branches. Many times I've seen divers stalk a fish up to the moment of pulling the trigger, only to be yanked back by an air-pressure indicator that has wedged in the coral. I could almost see the fish laughing.

THE TERRAIN

Complicating this stalking analogy is the undersea terrain itself. To approach a subject on land you might slip silently from tree to tree, using each trunk to hide you from your subject.

The undersea analogy to the tree is a large rock or coral head. In areas such as the Caribbean, the coral heads are often big enough to provide just this type of shelter. The ability to see but not to be seen allows you to spot your subject and determine your strategy before the subject sees you approaching and plans *its* strategy.

In other areas of the world such as Tahiti, the coral colonies are squat and strong as a defense against storms, so they offer little shelter. In this terrain you can use the edge of the drop-off itself as your cover. By keeping your body below the coral edge, the animals along the top see only your head and shoulders. My experience has been that they seem less threatened when they only see part of me.

There are some problems associated with working low to the coral. I've mentioned getting your equipment tangled or damaging the coral with your hands. You can do just as much damage to these fragile animals with your feet. Moving hand-over-hand is very efficient in

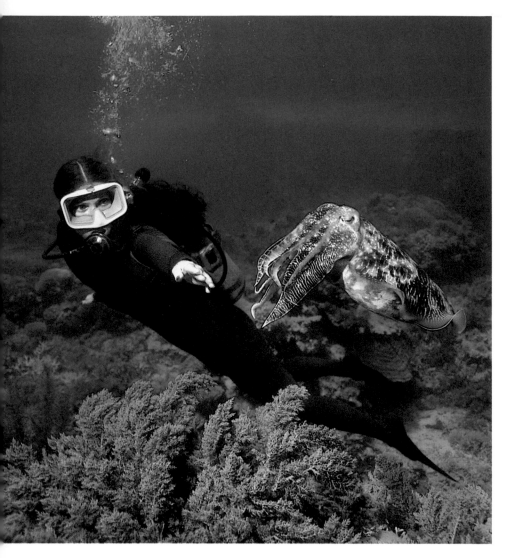

Working with large subjects requires real skill. The cuttlefish (above: Philippines) and the large grouper (top right: Great Barrier Reef, Australia) normally will not allow divers this close out of fear. We must win their confidence. Feeding sharks (bottom right: Maldives Islands, Indian Ocean) is a different matter. We must overcome our anxiety, work close to the sharks, and be precise in our timing.

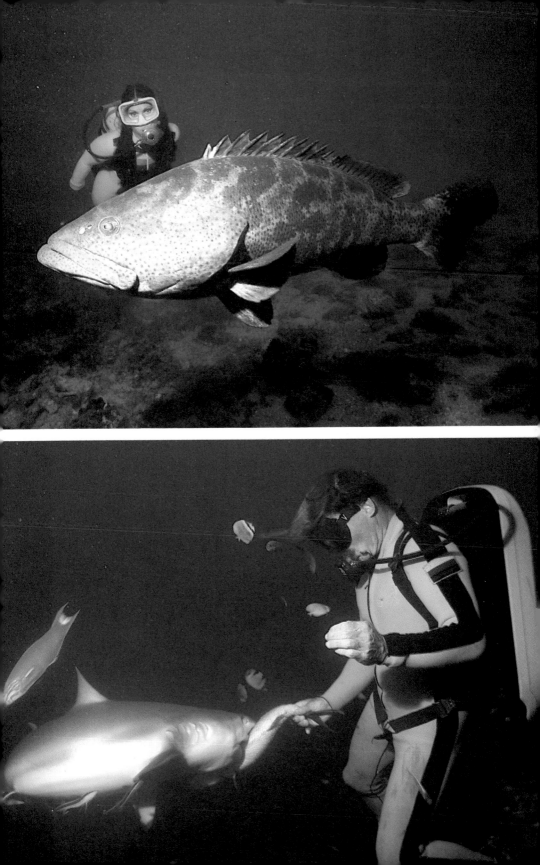

energy consumption if you simply trail your swim fins gracefully above the coral. If, however, you drag your feet because you are careless or are wearing too many lead weights, you will have the approximate impact on the reef that an Abrams tank would have on a flower garden. It is heartbreaking to see clumsy divers tumble irreplaceable hundred-year-old coral heads with their big feet. Not only do they destroy the reef's beauty and do irreparable damage to the ocean ecology, but their earthquakelike impact frightens off their potential subjects as well.

On a sandy bottom, thunder feet do less damage to the coral but lots more to the photographs. As you swim along, you'll see divers churning up clouds of sand as they stomp along the bottom. Now, let's say they discover a ray or a coral or a fish they want to photograph. When the flash or strobe light goes off, its light reflecting on the churned-up sand will make the scene look like a snowstorm. You may have seen photographs like this, or the less severe effect from minor scattering that looks rather like a starry night.

In my pictures I strive for a perfect black, deep blue, or reef coral background with no scattering visible. This is difficult enough to achieve when there is only one diver, the photographer, involved. It is doubly difficult when you are photographing one or more divers, because any of you may kick up the sand. In Chapter 7, I will show some ways you can avoid such problems.

BREATH HOLDING

Now to introduce a touchy subject. When I move about the reef, I expend minimum energy, moving slowly, scanning well ahead to spot potential subjects, and breathing very shallowly. I mention breathing because the sound of a diver's exhalations are very intimidating to reef creatures. Octopuses, lobsters, fish, and everything else that swims or crawls moves off as the disturbance draws near.

Earlier in this chapter I mentioned gliding in low to the reef with slow movements. Silence is obviously another asset, and holding your breath as you glide along achieves silence.

There's one problem, though: Holding your breath for *too* long could cause what is called *shallow-water blackout*. This phenomenon first arose among spearfishers who passed out after holding their

breath for two or three minutes while stalking fish. By training their bodies superbly to suppress the involuntary reflexes that force breathing, they went beyond the limit of safety.

I mention this now because in later chapters I will suggest that you hold your breath in order to get close to a wary subject; but I do not mean to have you approach the limit of safety. When you hold your breath, you should usually be motionless and have taken several breaths to oxygenate your system. Even then, a photographic breath hold usually requires something from several seconds to a minute. Going much beyond that is not recommended and can be dangerous, because shallow-water blackout can occur without warning symptoms.

The point to remember is that the reef creatures live in a world of subdued sounds. Clicks, grindings, squeaks, and soft rumbles fill the water, but they approximate silence compared to the noise a diver makes.

Evolving in that environment, reef animals are extraordinarily sensitive to sound. Sharks, for example, are so sensitive that they are usually seen only by the first one or two divers to enter the water. The cacophony of a dozen thundering humans generally sends even the most insensitive of sharks off into the blue.

Several times in the past, the diving industry has developed "closed-circuit" breathing apparatuses that release no bubbles but rather recycle the diver's exhalations. Only the very expensive and complex military versions have been successful to date. That means that for the time being, you'll have to breathe judiciously and slowly, or take shallow breaths. If you feel yourself getting light-headed, you're holding your breath too long. What we are striving for, after all, is unobtrusiveness, not unconsciousness.

There is no practice that will develop your photography more than practice in diving and stalking skills. I have mentioned a few tricks for approaching your prey and will discuss many more later. All of these techniques are simply molded into a smooth, quiet, nondisruptive presence on the reef. The more conscious you are of these points, the more you will find you develop your diving technique to include them. When you no longer even have to consciously think like a stalker, you'll be one.

THE ROLE OF LIGHT

In Chapter 1, I mentioned briefly the ways seawater affects light, and the consequent effect on photographs. Not only is the water partly opaque due to scattered particulate matter, but also it refracts the entering sunlight until only the blue end of the spectrum remains.

Early on, underwater photographers realized that only in the shallowest water could the sunlight render true color for photographs. Whenever you see a long vista of brilliant color in an underwater photograph, you are seeing a reef top only a few feet beneath the surface.

PORTABLE LIGHT SOURCES

Not content to show only this limited facet of marine life, underwater photographers began adapting hand-held lights for use in the sea. These lights bring out the normal full spectrum of sunlight in the small area seen by the lens. This immediately tells you that a larger, more powerful light is needed to cover the area seen by a wide-angle lens as compared to, say, a framer covering a mere few square inches.

Three types of lights have evolved in parallel:

1. Hand-lights, for the photographer to see true color, and to assist

in focusing. These are used for the diver to see darkened subjects and usually don't produce enough light to expose film.

2. High-intensity flashbulbs (now mostly obsolete) and strobe lights (the modern equivalent) to provide instantaneous, high levels of light in still photographs. The light pulse of a strobe usually lasts 1/1000th of a second or less.

3. Powerful floodlights or cine lights to provide sustained high levels of light for exposing motion-picture film.

For our purposes, strobe lights are our central concern.

After many years in the sea, I am still learning to understand the subtle interplay of darkness, shadow, sunlight, and strobe light. As I look at thousands of pictures taken with a variety of lenses, I can see almost unlimited variations of their kaleidoscopic tapestry.

THE BIG PICTURE

The simplest example to illustrate this weaving of light and darkness would be a wide-angle shot of a drop-off with sunlit water at the top of the picture and shadowed blue toward the bottom. The differing light values can be a marvelously dramatic touch, or they can ruin your photograph, depending upon whether the light and dark portions are too dark or too light.

To complicate the situation further, let's say that you also wish to artificially light a diver behind some colorful, soft corals on this vertical wall. Now you have four important light values to meld:

1. The sunlight at the top of the picture.
2. The deeper blue water at the bottom.
3. The corals nearer to the camera.
4. The diver a little farther away.

Parenthetically, not only must the light of these four elements be balanced, but you must also be sure that the lens depth of field at the f-stop you have chosen allows both foreground and background to be in focus.

As you can see, I am describing a simple-looking photograph which is in fact very complicated. For example, see page 34. I know many photographers who try to take variations of this shot and are crushed

when they don't get it the first time. Or many subsequent times.

The reef scene I have described is a blend of available-light photography (the background reef wall) and strobe photography (the soft corals and diver). The key elements to concentrate on are the soft corals and the upper-level sunlight. If you have f-5.6 sunlight in the upper frame, position yourself so your camera and strobe light are at a distance that will properly illuminate the corals for a f-5.6 lens aperture opening. The spillover of strobe light will adequately illuminate the model if he or she comes in close behind the target coral.

You might ask, "Why don't you concentrate on the human model instead?" Because you could very easily overlight or burn out the foreground corals, as well as run a high risk of having those close corals be out of focus. We will examine this further in Chapter 7.

Another interesting problem of wide-angle photography is strobe *coverage*. Some lenses see such a wide area that even a wide-angle strobe can't illuminate all of it. How can you beat that problem?

If you think about most good wide-angle photographs (other than pure reef scenes), the main subject or subjects are centered in the field of view. A lessening of light at the edges is not only acceptable but may even heighten the impact of the composition by highlighting the subject out of its background.

This does call for accurate aim of your strobe light, by the way. Many times have I seen underwater photographers boring in on a subject with their strobe light off at some odd angle. In one extreme case I saw a photographer hand-holding a strobe on a long arm, but the strobe was pointed directly away from the subject.

I prefer having the strobe on a fixed or ball-joint arm, which will tend to hold it at the angle I last set. Then before each photograph I always check the aim of the light. Sometimes I will even lay the entire rig on the coral and place myself three or four feet in front of the camera lens to see if the strobe is pointing directly at me.

Ideally, the centerline of the strobe beam and the centerline of the lens should converge precisely at the subject. That is true whether you are using available light to include a broader background, or whether you are purposely shooting against a darkened background to highlight the subject.

By the way, that last-mentioned type of photograph is perhaps the most common of all underwater wide-angle photographs. A lone diver, a solitary sponge or coral or shark taken against blue water offers the simplest shot from a technical standpoint. That's because you have a single subject at a single distance to focus upon and illuminate rather than coping with multiple distances and balancing light settings.

CLOSE-UP PHOTOGRAPHY

Moving from wide-angle to close-up photography simplifies certain problems. When the camera is two feet or closer to the subject, there is less background to worry about as you move in on a single subject. Moreover, problems of strobe coverage are lessened as the view field becomes smaller.

The easiest picture of all to take underwater is that of a motionless, or sessile (rooted), animal. Since a coral is stationary, you can take your time to examine lens distance, strobe distance and aim, and the composition of the picture again and again until you are satisfied you have done it all correctly. Many underwater photographers will take advantage of a sessile animal or colony to take several pictures at different f-stops. This is an insurance policy not only on your calculation of distances, but also on the reflectivity of the animal's surface.

A barracuda's or a tarpon's scales, for instance, optically resemble small panes of glass. Often, the brilliant light of a strobe will reflect back from these glassy silver scales and burn out the film image; it's like reflecting a powerful flashlight off a mirror into your eyes. Solution: Be sure that such a reflective animal is in a position that will angle the light *away* from the lens. You can imagine that this does become rather difficult when you have a group of milling animals in the picture. When shooting such a group, your only strategy is to take several pictures at different angles.

At the other extreme there are animals such as the bigeye, frogfish, and most black or dark red animals. These absorb much of the strobe's light. When you photograph them, you will sometimes capture only a dark, fish-shaped void in your picture. Eventually you will come to recognize which of the reef creatures fall into this category. The solution is very simple if you anticipate the problem. These animals

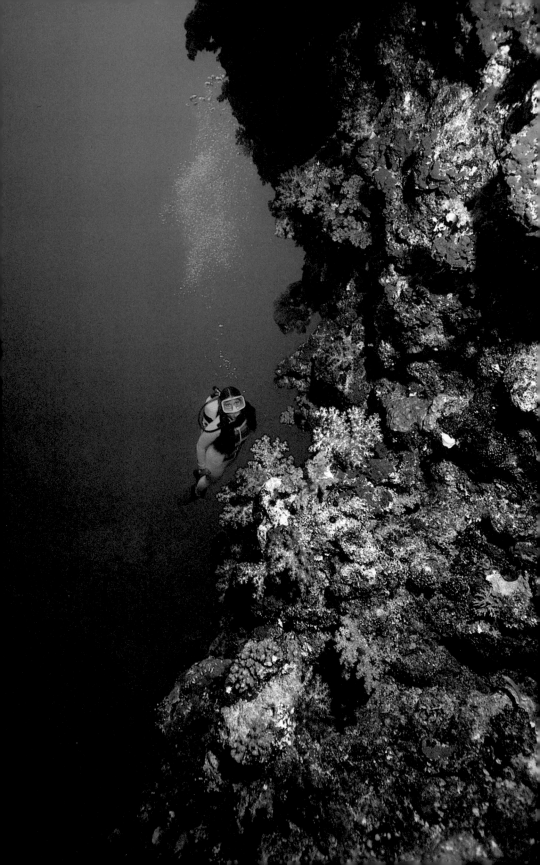

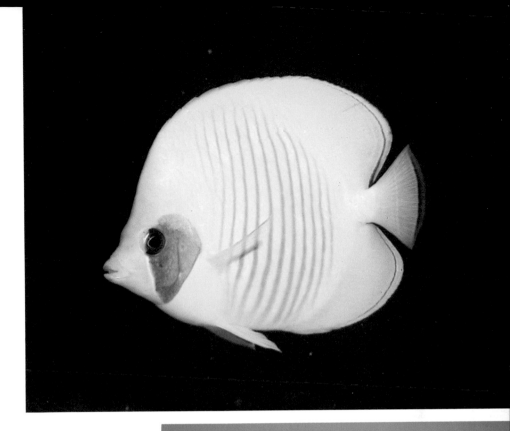

To "express" a reef
wall (left: Color Wall,
Fiji) or a manta ray
(bottom right:
Philippines) requires
mastering the
interplay of ambient
and artificial light.
Close-up photography
(above: Red Sea)
involves artificial light
almost exclusively.

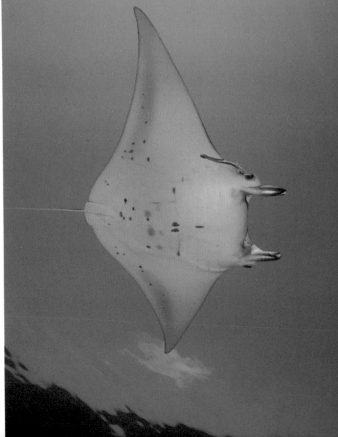

may require an extra f-stop or even two f-stops to produce an image of sufficient brightness. Your judgment of this condition will improve with experience.

BRACKETING

The process of taking several shots at different exposure values (f-stops) is called *bracketing.* When you are in doubt about the proper light value and the subject will stay still for you, it is a great idea to take one picture at the most likely f-stop, then one at a higher and one at a lower exposure. Of course, with fast-moving fish, sharks, sea snakes, or other swimmers, you may get only one chance. Then just calculate your best exposure quickly and go for the shot, because in that circumstance a minor variation in exposure value will often be overshadowed by the dramatic value of the subject.

AMBIENT VERSUS ARTIFICIAL LIGHT

On a shallow reef top brilliantly bathed in sunlight, you can measure the general light level of a scene with a light meter and take a picture with no other light source needed. However, with that single exception, almost any other underwater photograph demands the use of artificial light. The advent of portable lights made underwater photography in deeper water possible but also introduced far more complex variables into the activity.

Lighting in Close-up Photography

In close-up photography, only extremely stirred-up water or intense sunlight is a hazard. In most close-up situations the strobe is a foot or two from the subject, so most of its light will strike the object being photographed without scattering. Also, in water depths of thirty feet or more—or cold, green murky water of any depth—the light of the strobe is much stronger than the ambient light level. Thus, when the shutter opens after you pull the trigger, the film sees darkness; then the flash goes off and its bright light exposes the film to a very intense image.

When photographing a subject close-up in shallow water, on the other hand, lighting may become a problem. If you see the characteristic double exposure in a shallow-water photograph, as I described in

Chapter 1, it means that the sunlight exposed an image when the shutter opened, and the strobe light added a second image. If camera or subject was moving, these two images won't match. The result is for the eyes what running fingernails down a blackboard is for the ears. That is because you can *see* both images as a consequence of the sunlight and strobe light being nearly equal. It is often better in shallow water to let the sun do all the work, or go to deeper, darker water to find subjects for your strobe.

Wide-angle Lighting

Wide-angle photography, on the other hand, consists mostly of available-light photography with strobe highlights. With a wide-angle lens you are usually addressing a larger subject from a greater distance (three to six feet). Scattering tends to dissipate strobe light beyond six feet unless the water is extraordinarily clear. As the light from the strobe travels farther, it quickly falls to and below the exposure level of the surrounding filtered sunlight. Depending upon your depth and location, the strobe light and sunlight may be equal at levels as low as f-4 or as high as f-11.

Ideally, you want to use the light from your strobe to highlight your human model or other subject against the surrounding environment. At the same time, the strobe light will fill in shadows the sunlight has created on the subject. Sometimes I will photograph a model on a shallow reef and use strobe light merely to light the inside of the model's mask so I can see the eyes clearly. In this case the sunlight completely exposes the film and the lesser strobe image isn't even visible, except where the mask is shadowing the eyes from the sun. At other times, the strobe light will simply create on film a brighter, sharper image of the closer elements of your subjects.

In wide-angle photography, then, you have a hybrid between an available-light picture and a strobe-lit picture, with the latter in the foreground and the former as background. Only if you shoot in deep or dark water can you truly eliminate the ambient light from a wide-angle photo.

Cold, green murky water, as I said earlier, has little effect on close-up photos. What about the scattering that may occur in wide-

angle photographs? Well, it depends on the distance. Murky or stirred-up water definitely will degrade the quality of pictures taken at a distance of more than three or four feet. The light from the strobe is scattered and less effective; at the same time, the particulate matter in the water not only softens the crisp definition you would like to portray but also may show up as "snow."

However, one of the real assets of a wide-angle lens will help you in murky water: You can move closer, and the wide-angle lens will still see all of your subject. With a 15mm lens I can come very close to a diver and still get not only that diver but other subjects as well in the photograph. That means the strobe light fires through a shorter column of water, too, and more light reaches the subject.

The final result of this interplay of factors is that a wide-angle lens can make seawater appear much clearer than it actually is. This is often the difference between a classic shot and a throw-away.

Water as a medium is constantly influencing you, your subject, and the propagation of light from your light source. You can, however, usually predict and then compensate for these effects and so keep them from ruining your pictures.

This incredible arch offers a difficult lighting problem: You need the diver/model to size the arch, but under it he or she will be lost in shadow. The solution is to have the diver miniaturized in distant sunlight and use the nearby gorgonian fan as the ostensible subject (Astrolabe Reef, Fiji).

DEVELOPING YOUR SKILLS USING STATIONARY SUBJECTS

When you are just developing your techniques and technical skills, organizing yourself for any shot takes time. For any given subject you have to consider your body position and approach, the level of ambient light, the aim of your strobe, your proper distance from the subject (hence the proper exposure value), focus, and composition. Even all that doesn't cover fine points such as the reflectivity of the subject, or your possible effort to move the subject into the most attractive site or pose.

Under these circumstances, wouldn't it be nice if the subject stood still until you succeeded in getting ready?

Fortunately, the sea is filled with cooperative stationary subjects. A shallow reef top, a cluster of coral polyps, a feather starfish, even a Christmas-tree worm will remain as it is until disturbed. As long as you approach with the skill and caution we explored earlier, these animals will remain where they are for you.

Many of these stationary subjects are actually sessile, or rooted to the spot where you find them. Soft coral colonies, anemones, giant *Tridacna* clams, and gorgonians spend their entire lives attached by their holdfast to a coral substrate.

Other attractive subjects, while not rooted, take up certain posi-

tions that offer them access to good feeding, and remain motionless for an entire day or night before moving. Feather starfish, basket stars, anglers, scorpion fish, and others spend long hours in a single spot awaiting food.

A third group of subjects is not quite motionless; these animals move very slowly as they browse amid the corals for their food. This group includes the lovely nudibranchs and flatworms, which display some of the most vivid colors on the reef.

In addressing these subjects, it is fair to say that any problem in the picture is not their fault; they just sit there and are photographed. You can try anything you wish with them, providing you don't frighten them or kick them accidentally and knock them over.

The first rule is: Keep your distance and think through how you will carry out your approach. Often you can determine composition, best exposure, strobe aim, and whether or not you will bracket the exposures before you ever commit yourself. This is when the quality of the final picture is actually determined. Rushing this process is what results in badly aimed strobes and other mistakes. Sometimes I will sit for a minute or more running through a mental checklist, particularly if the animal is rare or one I have never photographed before. There may only be time for one shot (in the case of a Christmas-tree worm, which may retreat into its protective tube), or you may choose to shoot an entire roll of film on one rare sessile animal.

In any event, your success or failure is usually determined before you ever get close to the subject. Remember that, and you will go through your checklist just as a good pilot does—religiously.

1. How large is the subject?
2. How closely can I approach it?
 (Knowing the answers to questions 1 and 2, you have a good idea of the f-stop and the strobe aim.)
3. What body placement must I assume to get the most attractive angle on the subject?
4. Have I a clear path for the light from the strobe?
5. Should I move the subject, either for a better angle or for a more attractive background? Will it tolerate being moved? Will it be damaged or injured?

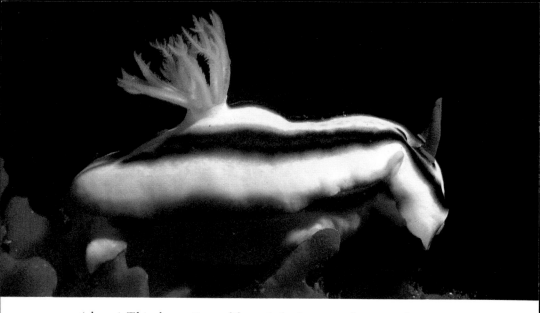

(above) *This dramatic nudibranch feeds on a red sponge. Its motion is so slow that for your purposes it is stationary (Philippines). A colony of feeding coral polyps (below) is an ideal stationary subject; still, you must approach cautiously to avoid having the corals retract their tentacles (Galápagos islands).*

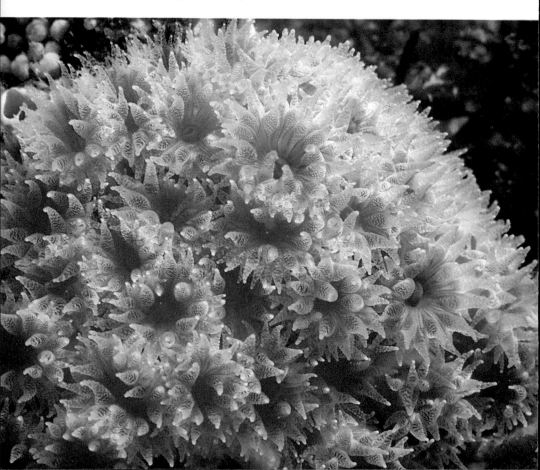

6. Is there some other, rarer subject nearby I will scare off by moving in on this subject?

Now, when you move in, you will be making minor adjustments in a well-thought-out plan. That's far superior to improvising on the spot; improvisation introduces unforeseen variables that may lose you your picture.

FRAMER SHOOTING

The easiest shots of all are macro shots with framers, in which you place the framer around the subject with the light pre-aimed at the frame and the f-stop at one setting (usually f-22) for the entire dive.

The clear advantage of framer shooting is that the fixed nature of the camera/strobe system precludes making changes underwater, and hence eliminates errors. Photographers who use framers enjoy a high degree of success, particularly with stationary subjects. Coral polyps, nudibranchs, flatworms, starfish, and mollusks yield themselves to excellent framer-shot photographs.

If there is a disadvantage to framer shooting, it is that you are committed to one frame size during the dive. Many a time I've heard framer photographers moan about the fabulous subjects they saw that were too large or too small for the framer they were using.

There are at least two possible answers to this dilemma. You can carry multiple framer-type rigs so you will be able to switch framers as the subject warrants, or you can consider switching to a housed camera with a focusable lens that will enable you to shoot everything from a barracuda down to a tiny Christmas-tree worm.

YOUR "EYE": COMPOSITION

Since the subjects mentioned above tend to remain motionless by definition, they offer you a good opportunity to develop your "eye." You may do mental spatial relation exercises: Should I shoot a vertical head-on shot or a full-body-length horizontal shot? (I recommend you do both.) Should I try to isolate this subject or combine it with another for a more interesting composition? (A fish amid corals or multiple, varicolored animals can tell a story that a solitary subject can't.) This helps your photography express what you have seen.

Still, most often you will probably seek an isolation shot to show the particular creature most thoroughly.

One effective method of isolation is to place yourself so your lens sees the subject against a blue-water backdrop. The reason for this is to prevent the strobe from illuminating some background distraction that will draw the viewer's eye from the portrait.

Often, however, you will find that you are forced to photograph the creature where it sits: amid coral, sand, or other background. One of the most frustrating combinations is that of a dark, light-absorptive animal on a white sand background. The strobe light tends to overexpose the background or underexpose the subject.

Sometimes in this case you can move the subject. If not, you might try propping it up to bring it away from the sand. I tried this recently on a burgundy-colored frogfish (it's the one with the fishing-pole lure on its nose to attract the small fish which are its prey). Frogfish are sedentary and very poor swimmers. Knowing this, I used my free hand to block its escape; as the fish and I jockeyed for position I finally managed to capture it flared and upright. At close camera-to-subject distances, a mere inch or two of separation between subject and background will sometimes be enough. By managing to get the fish in a vertical orientation while the sand remained horizontal, the glare from the sand was greatly diminished; the fish stood out even though it was much darker than the surrounding background.

Trying to handle the subject to improve its position does entail risk. A delicate feather starfish (crinoid) will fall to pieces in your hand. A feather-duster worm will retract its beautiful feathers into its ugly tube. A fish may dive down a hole and stay there until you run out of air. There is a lot of trial and error involved, about which I would like to stress two points.

First, if you miss one subject—because it disappeared down a hole, let's say—there are always others. Don't fret. I have lost good subjects only to be thankful later in the dive when something really spectacular showed up and I had film left to shoot it.

You'd feel silly if you shot all your film on a butterfly fish or corals, then later discovered a rare frogfish or leaffish or Spanish dancer.

Second, keeping some type of photo log is advisable during the technique-building period.

THE PHOTO LOG

Some divers will carry a plastic slate and pencil and, for each shot, record the distance, f-stop, and any thoughts they have regarding the subject. Later, when they sit down with the results, these on-the-spot data and thoughts can be invaluable. You will find this particularly true when you are trying to photograph reflective, absorptive, or complex subjects. It will not improve the pictures you have already shot, but you will avoid repeating your errors.

When you do this for years, your memory will accumulate experience and usually warn you of complications, even as you first spot a subject. Early in your career, however, you don't possess this cumulative knowledge. An underwater log, or even a diary kept on the boat, can quickly develop your instincts and habits.

To show how valuable a log can be, consider this: When you find a beautiful stationary subject, you may want to photograph it from several angles. For each angle you may want to bracket your exposures, taking one picture at the most likely light value, or f-stop, plus one higher and one lower f-stop as insurance. Back home a week later you may be staring at twenty pictures of that animal, trying to remember exactly what your lens settings were and what was going through your mind back in the water. If you had recorded these photos in a log you could easily determine what logic worked—and what did not. By accurately reviewing your successes and failures, you can usually avoid repeating the mistakes.

DEFENSIVE PHOTOGRAPHY

I have often seen divers shoot thirty-six different subjects in a roll of film with thirty-six possible exposures. To be successful with that approach you would have to be a very good photographer indeed. In a typical dive I will shoot five or six subjects, taking several shots of each. On many occasions I have shot an entire roll or even multiple rolls on a single subject, particularly when I am shooting rare animals I may never see again. After all, I can never tell when a strobe, camera, or film problem will cause me to lose pictures. *Think insurance.*

This insurance, which might be called defensive photography, can be in the form of several exposures, multiple rolls of film, or even

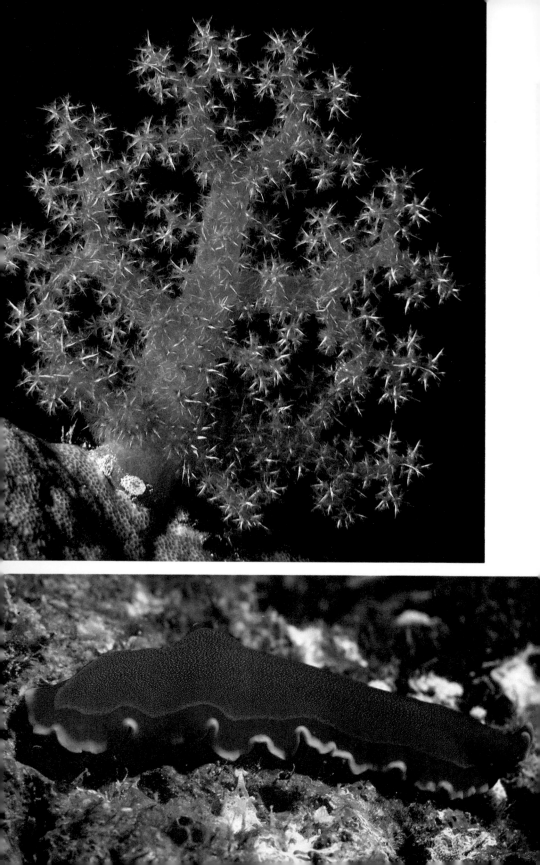

Practicing your techniques on stationary subjects enables you to develop your own portrait style (top left: *soft coral, Ponape, Micronesia;* bottom left: *a flatworm, Fiji;* above: *the rare scorpionfish,* RHINOPIUS APHANES, *Papua New Guinea).*

multiple cameras. Film is usually the cheapest part of a diving trip. Don't be afraid to shoot. You will never get a picture if you don't pull the trigger.

LARGE STATIONARY SCENES

While I have concentrated on smaller stationary animals in this chapter because they offer you excellent opportunities to develop your own technique, I should mention larger stationary scenes also.

The most common of these are shallow reef tops and huge drop-offs into deep water. Sunken wrecks fall into this category as well.

The factors involved in taking pictures of such scenes are lighting, visibility, scale, and composition.

Reef Tops

When you are shooting a shallow reef top in bright sunlight, lighting and visibility are usually good. If you have a pleasant composition you need only decide whether or not to include a diver for scale. For smaller subjects such as crinoids, cuttlefish, and soft corals, the lack of scale humans is no problem; you should probably use a 50mm or 55mm lens rather than a wide-angle, and let the color and form of the animal itself be the entire composition. But larger subjects, such as a reef top or drop-off, can look much more impressive if a human whose size we can comprehend shows how massive the scene really is. We will discuss scale further in Chapter 7.

In these large scenes it is important to hold the camera as steady as possible, even bracing yourself on coral. These shots are often taken at slow shutter speeds of 1/90th or 1/60th of a second in order to synchronize the shutter with a strobe fill. This fill is intended to maximize the color and sharpness of the closest corals or fish so as to highlight them in the overall scene. All this works successfully, but remember that slow shutter speeds in ambient light situations will leave you vulnerable to blur if the camera moves.

Vertical Coral Walls

Large drop-offs pose certain problems, which I mentioned in Chapter 4. When a drop-off scene is shot with a wide-angle lens, you are faced with the difficult transition between a silhouette shot (looking directly

upward) and a scene of darker blue water, plus a wall to illuminate (looking laterally). Underwater photographers almost never shoot downward.

In the excitement of photographing such a vertical coral wall, you will often find the greatest drama in the midrange between the lateral and vertical view. This is particularly true if you have dramatic, colorful life on the wall and divers swimming downward toward you. Be alert to the fact that just a few degrees of upward incline can dramatically alter the lighting of your shot. Looking laterally, an f-4 or f-5.6 may nicely balance your strobe light on the foreground corals with the backdrop comprised of blue water and perhaps divers.

Now elevate your sight a few degrees and you'll suddenly have an f-8 or f-11 backdrop of brilliant light water silhouetting your foreground corals and drowning them out. This will require you to get your strobe closer to the corals to get f-8 or f-11 light on them to balance with the bright background.

Often you will find that it will pay to retreat from that upward angle and take the picture laterally. This is simply because a strobe light is no match for the sun in shallow-water situations. Unfortunately, that may preclude your getting the precise effect you wish.

In any event, in all reef-top and coral wall shots, remember to keep that camera steady.

Sunken Wrecks

Sunken wrecks pose a few special problems in lighting which are similar to those of reef-top and vertical coral wall scenes. Commonly, wrecks are found in areas that are characterized by murky or rough water. This, plus their large size, makes it difficult to show entire wrecks in any single photograph even in the best of circumstances.

As a result, an underwater photographer will usually try to find some symbolic portion of the ship (a deck gun, the bridge, a mast, a davit) to symbolize or evoke the idea of a sunken wreck. Working with this smaller scene, you can use your artificial lights to good effect, by highlighting colorful marine growth on the metal. Even so, many wreck shots turn out to be available-light shots or even silhouettes because no strobe could illuminate such a large scene.

As in the drop-off or reef-top scenes, holding the camera steady and

using the widest-angle lens you can enhances your ability to get the shots you seek. Wrecks in cold water are usually in very dark surroundings but in tropical seas they are much easier to photograph. While a wreck off New Jersey or California may be impossible to express on film, I take our See & Sea groups to one small Japanese fishing vessel on a shallow clear-water reef in the Philippines which is ideal for these shots. Several of Truk Lagoon's sixty-four sunken Japanese freighters and tankers also offer magnificent scenes, as you can see in the photograph on page 11. When, however, you try to photograph something as colossal as the S.S. *President Coolidge* in Vanuatu, you find even a bow gun or bridge wing is almost too big to capture on film.

As you can tell by the plethora of subjects covered in this chapter, there are an extraordinary number and variety of stationary subjects on which to sharpen your underwater photography skills. In traveling the world with divers, I find that while the range of subjects is staggering, the techniques discussed here hold, no matter which ocean, reef, wall, or wreck we are diving. Do you have to make minor adjustments for crystal-clear versus somewhat murky water? Of course. Still, the use of silhouetting, the use of divers to show scale, and the balancing of ambient and strobe light are always appropriate. If you give yourself time to think out your plan, which any stationary subject allows you to do, you will soon be shooting high-quality photographs regularly.

SIX

LARGER MOVING TARGETS

In these next three chapters we come to the heart of underwater photography. What's past is prologue, as Shakespeare wrote. The photographing of reef tops, walls, and smaller motionless subjects hones your skills so you can attack the big three: large animals, human models, and the shy reef fish. In any slide show, magazine article, or book dealing with undersea themes, the most exciting segment is always that regarding the big animals. That does not necessarily mean sharks. Manta or eagle rays, big turtles, dolphins, and whales are all capable of setting the heart on edge.

These larger targets have special characteristics that make them difficult for the new photographer to successfully capture on film.

THE SURPRISE FACTOR

One reason these animals are so difficult to photograph is that they often come upon you when you are not expecting them. You may be trying to photograph some small animal up close and *bang*, a big animal is suddenly there. One day in Australia I was photographing a small yellow hydrocoral with a blue-water background. Looking through the eyepiece, I suddenly saw something massive moving in that blue background. I lifted my head and was stunned to see a young

whale shark some twenty-five feet in length swimming directly toward me. It was following the small coral valley in which I was photographing.

Of course I was holding my close-up housing, and my wide-angle camera was some distance away. I laid down my close-up rig, pulled myself hand-over-hand to my wide-angle camera, and raced back to my original spot. The whale shark got there first, and while I had the enormous thrill of seeing it broadside, I had not reached the proper vantage point to get the shot I really wanted. That spot would be ahead of the shark and slightly to one side, by the way, so the head and eyes would dominate the picture while the body trailed away.

Broadside shots of really large animals like whales or whale sharks require incredibly clear water simply because of the distances involved to get the entire animal in the picture. Shooting from three-quarters forward improves the visibility a little by moving close to the most expressive portion of the animal and highlighting that.

CONTROLLING THE EVENT

With larger animals you move from having control of the scene as you do with stationary subjects to having practically no control. In this situation two elements will dominate: your swimming and diving skills; and your ability to think quickly and accurately under pressure. These will make the difference between great pictures and no pictures at all.

When one of these magnificent creatures shows up, you may have no time whatever to prepare. For example, I was recently putting on a shark-feeding in Australia for a group of divers I was guiding. At this particular reef, the boat crew rigs a wired bait of several fish, which brings in ten to twenty gray reef sharks for some spectacular action. By allowing the divers to preset themselves on a reef, and staging the action right before their cameras, we achieve unique photo opportunities.

It was at the end of the feeding; the sharks had gotten excited, attacked the bait, and eventually became sated and calm again. Not wanting to leave litter at the site, I swam over to pick up the leftover bait and noticed that there were a couple of uneaten fish heads left on a wire leader.

Since I had worked these sharks for ten years I was unafraid and perhaps a bit careless. I decided to lay down the bait and kneel down behind it to photograph one or more sharks coming in for a final bite. Keep in mind that these are five- to six-foot-long sharks, and although they are intimidating in numbers they are fairly safe one at a time.

As I got into position, I looked up to see a stunning apparition. A fifteen-foot hammerhead shark had been drawn to this area by the sounds of the smaller sharks feeding, and it was bearing down on me like an express train. The shark was so large that when its pectoral fins brushed the sand, its huge dorsal fin was more than head-high.

It swept directly up to me, flared its immense pectoral fins, and skidded to a stop, its great eyes on a yard-wide hammer-shaped head ominously flicking from the bait to me and back.

There was nowhere to go, so I took a picture of its face. At the flash of light it raced away in a tight circle and came right back to me. I took one more picture as the shark decided that the fish heads, and not the photographer, were its food. It extended its great jaws and devoured the bait, getting the wire leader tangled in its teeth as it ate. I cannot tell whether the story would have ended differently without that wire. Perhaps the shark would have come back for some of me. In any event, the wire in its teeth annoyed it greatly, and when a fifteen-foot shark is annoyed, it races about like a runaway streetcar. At this awesome sight, the small sharks and divers exited in a hurry, and we all spent the next three days reliving the hammerhead moment.

These incidents illustrate how you must be mentally and physically prepared to act in such situations with no chance to think. You have to be able to mentally shift gears from whatever you were doing to a sudden high-voltage confrontation!

PREPARING FOR CONFRONTATION

What can you do to increase your chances of reacting properly in these moments? One good technique is to keep a camera rig ready for these sudden opportunities. I keep a Nikonos camera with a 15mm lens preset at f-5.6 and a three- to ten-foot depth of field. An attached wide-angle strobe is set at a point five feet in front of the lens. Now,

when any animal comes upon me unexpectedly, I can simply pick up the camera and shoot.

That setting combination works in a wide range of clear-water situations because it anticipates the average ambient light and also exposes the human- or shark-sized subject to a burst of action-stopping strobe light. You may want to alter these settings for particular situations. Some bright reef tops require an f-8 aperture, while the light at the foot of a reef wall may be f-4 or less. Be careful in the darker water, though, because in the absence of ambient light your strobe will be more effective at close range. If your target comes to within three or four feet and your lens aperture is set at f-2.8, you may well overexpose your subject with the light of your strobe.

COLOR IN LARGE MARINE ANIMALS

One interesting fact: The larger animals in the sea tend to use what is called *obliterative countershading* for camouflage. This means that the upper portions of their bodies are dark and their bellies are near-white. In the open water, sunlight striking them illuminates the dark upper body, while the belly remains in shadow—the animal tends to simply blend into the background. It is an extremely effective camouflage. Some larger animals such as the great white shark are so skilled in approach and so brilliantly camouflaged that they are often right next to you before you ever see them coming.

One critical word of warning: I always shoot these ultimate marine predators from within a shark cage. The need for the cage is obvious when you recall that these animals run to fifteen-foot lengths and weights of well over a ton. Moreover, their normal diet consists of sea lions, porpoises, and rays—all wary animals, skilled swimmers, and about the same size as a photographer.

In the green, often murky, South Australian waters these great sharks prowl, I have found it best to float the cage near the surface to get as much sunlight as possible. In these circumstances I do not use a strobe for two reasons: The murky water will cause backscattering; and the animal is so large the strobe would only illuminate a tiny portion of it anyway. Using sunlight involves only one important rule: Keep the sun *behind* you so it falls full upon your subject. Only in a silhouette-type shot do you use the sun behind the subject.

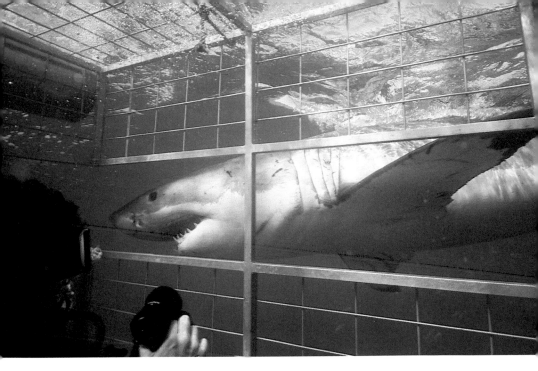

Photographing great white sharks takes total concentration, for your moments with these ultimate photo subjects are few—and quickly over (Dangerous Reef, South Australia).

TIMING

If lighting isn't the key to this type of picture, what is? In a word, *timing*. The reason for the mental preparation is simply so you will not miss that moment when a huge animal places itself in just the right position for you.

Consider the bottom photo on page 27. In it, my friend Herwarth Voightman is hand-feeding a gray shark. The essence of this picture is the violence of the particular moment. The shark's eyes are rolled back to protect itself from its prey's lashing tail or fin putting out an eye, and its powerful jaws have just clamped on the fish. Herwarth's body conveys a range of emotions; I am reminded of photographs of toreros in bullfights.

In this case the water was so dark and the action so fast that an available-light photo with a larger aperture would have been a blur. For this reason I used a 24mm lens and moved in close so the strobe's instantaneous flash would allow me to shoot at a faster shutter speed and so stop even this fast action.

While this photograph is an obvious timing shot, most large-animal work involves precise moments when the composition is right. This is especially true when there are two or more animals in the picture, or a diver together with a sea creature.

How do you recognize these moments? Early in your career it's very possible you will miss them just as a beginner misses an oncoming baseball or tennis ball. After you have gained some experience, though, you'll see that every perfect moment has an action lead-in. That is, with experience you will see a perfect shot shaping up as the action unfolds. For example, a shark approaches some bait and you wait for the moment of impact when the bullet head raises and the eyes roll back. Or a manta ray slowly angles in and you wait for it to be placed perfectly under a ring of bright water (see the photo on page 35). Or a sea snake rises from its coral bed heading for the surface and you wait for your model to come in behind it and reach out to touch it (page 58).

One caution with these shots, though. The moment you are waiting for may be over in an instant: In the sea snake and diver photo, once that diver touches the snake it may abruptly race away and leave you with no picture at all; once the shark bites the bait it will race away to devour it. Therefore, in wide-angle shooting, it may be better to err on the side of pulling the trigger, even shooting too soon, than on losing the opportunity altogether. This also means that you should not risk missing the dramatic subject waiting around for the scalar diver to appear, either.

BEING PREPARED

Since you don't want to miss the dramatic subjects, how can you mentally set yourself to prepare for them during your dives?

One difficulty is that you may see a thousand small close-up subjects in the course of a dive but only one or two important wide-angle subjects. Moreover, when you work on close-ups, you are working very close to the reef and may miss larger animals passing behind you in open water. Remember this simple fact: If you miss out on a close-up, there are always more; if that rare shark or turtle or ray presents itself, you will wish you had saved film for it.

To avoid such frustration, it is often best to simply hold off on, to

ration, your wide-angle shots. I will often lay my wide-angle rig carefully in the corals and spend most of my dive patiently stalking close-up subjects.

I always try to be alert to the possible approach of a wide-angle subject, though. As in the whale shark incident I mentioned early in this chapter, a dramatic wide-angle target may come at you right in the middle of shooting a close-up subject. You must mentally shift gears very quickly. If your wide-angle camera is preset to a standard setting such as I described earlier, you must then decide whether the new subject fits the standard. The whale shark, for example, almost certainly requires new settings. It is too big for the strobe to be effective unless it swims right to you, so you will be shooting it with available light only. You may also have to change focus.

STAYING COOL

One big factor that may not be obvious at first is your adrenaline level during these situations. If you are out on a reef and a huge turtle such as the one on page 58 swims toward you, concentrate on one thought —*I may never get a chance for this again, so do it right this time!* Your next concern should be to avoid frightening it off. That may require that you hold your breath to avoid the noisy disturbance of exhalation.

You are crouched motionless, not breathing, your heart pounding with excitement as this magnificent giant glides toward you—now how on earth are you going to remember f-stops and focus and strobe aim and proper angle and composition?

With great difficulty. Fortunately, knowing that this is your one chance ever at this animal concentrates the faculties, calming you down so that you find you do think clearly.

GOOD HABITS

How can you maximize this concentration? One way is to develop good habits. I try to do things in certain ways without varying so that under pressure these habits themselves will work in my favor. I mentioned using standard midrange camera settings. Another good habit is to simplify exposures in your mind and relate them to certain key situations, similar to the way camera manufacturers have tried to

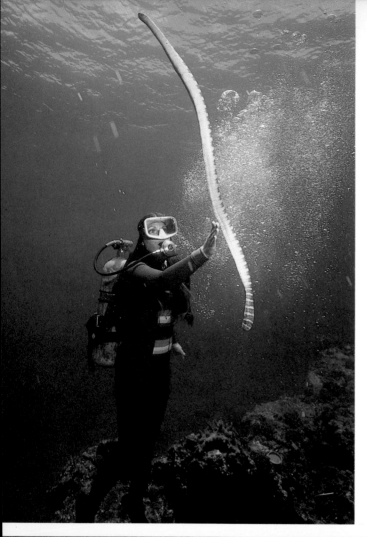

Maneuvering yourself, a large subject, and perhaps a human model as well requires concentration and timing (left: Jessica and a sea snake, Philippines; below: Great Barrier Reef, Australia; right: Maldives Islands, Indian Ocean).

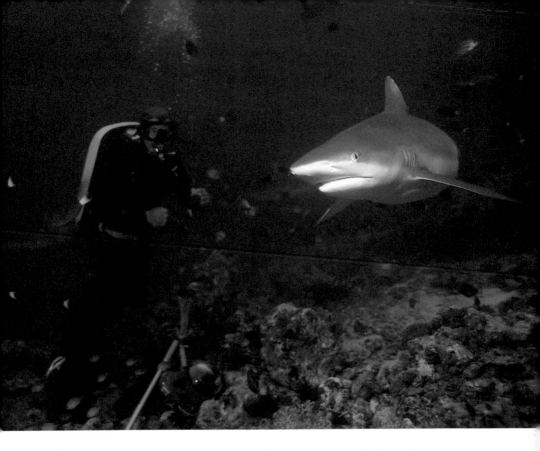

describe exposures to novices as "bright sunlight," "hazy bright," "overcast clouds," and so forth.

I have learned through the years that in tropical waters with certain film and shutter speeds I can standardize certain scenes. For example, with the usual ASA 64 film and 1/60th shutter speed (to synchronize with a strobe) I use, certain situations demand certain f-stops. In clear, tropical water less than fifty feet deep, I look up to see if the sun is in the picture. If it is, f-11 is right. If the sun is out of the upward-looking shot or blocked by the silhouette of a boat or diver or ray, then the f-8 setting will usually be right. Knowing these to be reliable, I can count on them in a fast-developing situation with a big animal.

YOUR OWN SYSTEM

To some extent, only reviewing your own personal experiences with the luxury of hindsight and your photo log will develop your style. Your system, whatever it is, will be *your* system. What I am suggesting is to begin your career thinking in terms of developing such a

system. Then you will have a mental framework into which you can place your experiences. I have spent long hours studying my photographic results to see how they could have been improved.

COMPOSITION

In photographing larger animals, I have mentioned earlier the fact that they tend to black or gray in upper body color. Pictures of these ocean dwellers can often be as effective in black-and-white renderings as they are in color. The essence of these portraits is composition and timing. You are looking for that moment when the body turns, or the animal soars in with its head raised to look you in the eye. The colors, since they are principally gray and blue, resemble in some ways the silhouettes we discussed in Chapter 1. The flow and shape of the action, and not the brilliancy of color, are the story to be told.

SWIMMING AND DIVING SKILLS

More than other types, this class of photographic subjects will test your swimming and diving skills. Obviously, that is because these animals spend most of their lives moving.

A reef top, a coral, a modeling scene, or even a fish portrait can be taken without your having to swim far. With the big animals, on the other hand, you are in a moving ballet in which your subjects have all the advantages. They are the great, graceful soarers, and you are the awkward intruder. Given that relationship, there is a great deal of satisfaction in coming away with their essence on film.

One advantage you do have is the animal's innate curiosity. Confident in their swimming ability, they will angle in to study you, and that curiosity and confidence often hand you your opportunity.

In these situations the one error that will always cost you is sudden or fast movement on your part. It is taken as a predatory attack by many prey animals such as turtles, rays, or even sea lions.

What you want to do is achieve a position and do it smoothly. One of the most effective ways is to get coral between you and the subject when you are moving to your new position. Not only are you invisible to the subject, but coral handholds may allow you to move more rapidly than swimming. The obvious problem? Your exhalations. They are so noisy and visible to animals that they are a dead giveaway.

You may hold your breath and move behind small coral heads to achieve an improved shooting position, but the need to breathe will limit you to rather short distances. On the other hand, I have on occasion made fifty-yard swims around large coral structures to approach a resting animal successfully. Nurse sharks, some rays, and turtles do not like to give up a comfortable bed any more than you do, and that is a strong factor in your favor.

APPROACH STRATEGY

Recently, in the islands of Palau in Micronesia, north of New Guinea, I came upon a young hawksbill turtle lying on a soft bed of algae. I swam in gently, perched right next to the turtle, and shot a number of pictures. After a while I slowly put down my camera and cautiously reached out and picked up the turtle. Because this was all done without any sudden motion, the turtle did not struggle. I swam it around to be photographed by several members of my diving group, then brought it back to its bed of algae and gently placed it in its original position. It seemed to utter a sigh of relief and stayed right there. I have had similar encounters through the years with rays, nurse sharks, zebra sharks, turtles, and other large animals.

Sometimes, as you study an animal, it will give you a good idea of whether you can approach it. On one trip to the Coral Sea in Australia, my wife, Jessica, and I were on the dive boat when some members of our party came aboard excitedly burbling about a huge nurse shark they had seen in a valley. Entering the water, we followed their directions. Sure enough, we came upon a nurse shark ten to twelve feet long, lying on the sand.

Our approach strategy was for me to come in low and slow and get close to the animal without frightening it. Jessica, meanwhile, made one of those long swims around a great coral tower to approach the shark from the opposite side. We managed to take a number of pictures which really expressed the shark's size (see pages 62–3 for one example of the result) before it disgustedly gave up on its nap and lifted off into the blue.

Another wonderful encounter occurred recently in the Philippines, where I was in the water alone when I saw a young manta ray. I got

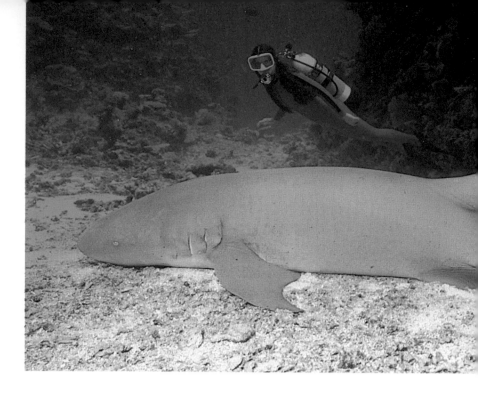

behind a small coral head and remained motionless, peeking out at the approaching animal. I had used this technique before on the mantas and found that it seems to pique their curiosity. The ray glided in until it was almost close enough to touch. I shot an entire roll of film with the ray as it hovered to my right, then my left, then soared over me to silhouette itself against the sun (page 35). We explored each other thoroughly and became such friends that every time I entered the water in the next two days the ray would soon come to play.

Barracuda are curious, as well. These much maligned fish are harmless under all normal circumstances; they just *look* fierce. In Palau recently I was in the clear waters near the Quadruple Blue Hole when several hundred barracuda appeared in a silver cloud. Absolutely enthralled, I swam out into the blue water out of sight of the reef and found this colossal shimmering curtain of barracuda completely enveloping me. Forming a great cylinder with me in the center, they wheeled slowly about me. For several minutes this formation remained intact while I tried somehow to capture it on film. As you see

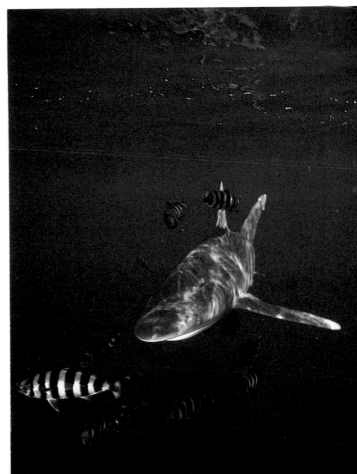

Successfully approaching large sharks produces the most rewarding of pictures (above: Coral Sea, Australia; right: Red Sea).

from the photograph on page 10, it could not be captured. Even a 15mm wide-angle lens could only capture a small arc, perhaps a twentieth, of the great cylinder. There are experiences we capture in our minds and can play back at will yet never can share with anyone else. Not only our cameras, but also our descriptive skills are inadequate to express these incandescent moments.

Divers have often asked me, "Isn't shooting big animals all the same? I mean, there's the animal and there's the water, right?" Wrong, oh, so wrong. You should not be after just a picture of the animal. You should be trying to *express* that animal to other people who did not experience it. Anyone can point a camera at a big animal and pull the trigger; but to have that animal show you its mood and personality in the turn of its head or the angle of a fin is something else entirely. To have it evoke something of that profound world that is the sea, conjuring a story far beyond the mere moment of the photograph, is an even greater accomplishment.

In many ways, when we capture the spirit of a large sea creature we have looked into the face of life—or death. We have invoked the mysteries that lie in the unknown reaches of the sea. In the case of some of the most phantom of predators, such as the immense hammerhead or the great white shark, we can even face our own personal gods and demons.

There are parts of your undersea adventures that you will never capture on film. . . .

WORKING WITH HUMAN MODELS

Years ago I entered an underwater photography competition and discovered that any photo including divers fell into a category ominously called "Men and Equipment." Makes you think of hard hats and bulldozers, right? Well, so did the pictures; the divers were all burly and lumpy, and often had tire irons in their hands (for prying abalone from rocks).

In the early days of the sport, most American diving was done off the U. S. coasts in cold, green water. Consequently, divers wore heavy, bulky wet suits with huge amounts of lead weights. The science-fiction effect that pervaded these cold-water photographs persists to this day.

With the advent of diving travel to warmer climates, however, diver photography underwent a profound metamorphosis. Instead of macho power, the exotic scenery now called for beauty and grace. Women began to replace men in the pictures, and diver photography began its evolution into modeling.

LENSES AND LIGHTING

From the camera equipment standpoint, model shots are like large-animal shots, so most of the commentary on equipment in Chapter

6 applies here, too. For example, wide-angle lenses such as 15, 21, 24, and 28mm let you get closer to your subject, achieve sharper features because you're shooting through a shorter column of water, and enhance the clarity of the water as seen in your photographs.

Similarly, wide-angle strobes can illuminate this wider field of view. True, many model shots feature the model in the center of the picture surrounded by blue water, and you don't always need to light the entire frame. Still, what happens when your model is in a coral setting or a large school of fish, for example? For such occasions you certainly want a strobe with at least a ninety-degree or better angle of coverage.

——— PROS AND CONS OF USING MODELS ———

The reasons we include divers in our photographs tend to explain that inevitable evolution from macho to graceful subjects:

1. To add the drama of human scale to a scene or animal. We can instantly transmit an understanding of how big a coral head or a fish is by juxtaposing it with a diver.

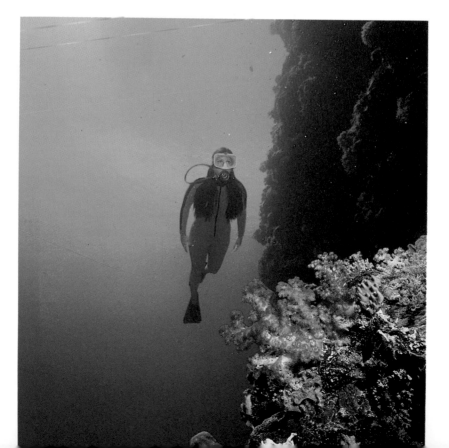

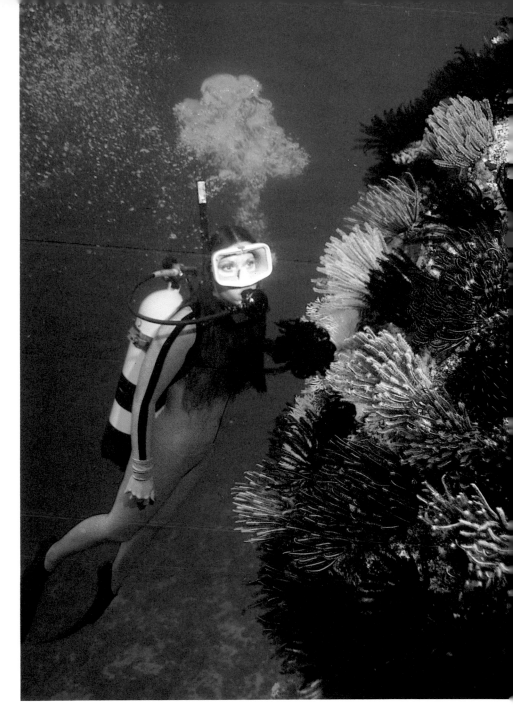

Balancing strobe fill with available light is one of underwater photography's most difficult skills (left: Jessica on Ngemelis Wall, Palau; above: with a colony of crinoids, Coral Sea, Australia).

2. To give a feeling of participation, as if inviting the viewer to join in. After all, your mind tells you, that could be *me* in that picture.
3. To vary a series of pictures of one pretty animal after another. Even superb portraits can be boring in an unvarying succession.
4. To achieve an emotional content, showing a diver and a reef creature interacting with each other.

There are, of course, some obstacles to producing good diver shots. For one thing, a lot of the equipment divers wear still looks like astronaut suits. There are straps and hoses, meters and gauges sticking out, distracting the viewer's eye. Over the years, the advent of all kinds of additional equipment has only made the problem worse.

Then there is the delicate problem of the model's gracefulness. As I have discovered by working with my wife, Jessica, an underwater model must be as disciplined, trained, and organized as a high-fashion studio model. Unless a diver is willing to give up the fun of his or her own dive to *work* as a model, that person will tend to look clumsy.

Add to this the further complication of interplay between human and animal. Many divers may feel an uneasiness or distrust of animal subjects, rather than a visible joy. This tension is expressed in stiffness or restraint, a body language that transmits itself clearly and tends to ruin the picture.

The animal, too, may become nervous, may move into an unflattering position, or even be frightened off entirely during the course of your effort. You and your model have to be skilled enough to keep the animal in your scene. In addition, you as photographer must properly light both your model and any other critical elements of the composition in a *balanced* way. It won't do to illuminate the model's face perfectly only to have the fish in the foreground overexposed.

The use of a model creates a complicated interplay, to be sure. When it works, however, you may find your biggest audience reaction from the results.

WORKING WITH A MODEL

How can you approach taking model or diver pictures to develop your own technique? That is, how do you satisfy your own mental vision? I am purposely expressing the question in these terms because every

photographer may borrow, but in the end success comes from your own individual style.

Let's take this development one step at a time.

Communication

You begin developing your technique by realizing that model pictures are a special subset of both stationary-subject and larger-subject photography. That is to say, the model is either part of a stationary scene, or you are juxtaposing him or her with some animal or group of animals and recording their interplay.

The first problem is to communicate your vision of the shot to the model in some way. When I work with Jessica, we try to anticipate shots and discuss them even before entering the water. That is possible when you are diving a particular site whose terrain and marine life you know well or even a site that is reputed to have certain types of life you may anticipate. When another diver emerges from the water and tells us there is a moray eel or giant soft coral at the site, we immediately begin visualizing the composition we want.

When photographing large subjects you may, for example, wish to show a tunnel in the reef by having the model emerge from the mouth of the tunnel into the camera's field of view. Or you may want the diver in the distance to emphasize the grandeur of a huge precipice.

For small subjects, you may want your model to actually hold the animal, showing it in various attitudes. Although it is not essential to the composition of a small-animal photograph to include a scale human figure, a crinoid or starfish or shrimp is imbued with a new, human dimension beyond its normal inertness when held in the model's hand. This vitality enhances the animal's own beauty, a synergy that can make for a superb shot.

On the other hand, if your model tries to touch a fish or ray or turtle, it may swim off and be lost for good. Approaching these animals involves judgment as to what your approach will do, and different individual subjects will react differently to your approach.

If you come upon some unforeseen subject of opportunity, however, how can you communicate what it is you want when you are in the water? How can you tell your model to pick up the animal, swim

over it, circle behind it, or whatever effect you wish?

Jessica and I find that a simplified set of hand signals works well. After looking at many pictures together to determine how to improve them, I can now tell her what path to swim to bring her into the desired relationship to the subject. That may be to swim across and above a large gorgonian fan or come in right behind a fish so that the camera can see her eyes as she looks at the subject. Both of those routes can be portrayed with a simple sweep of my hand.

Hand signals should also be agreed upon to tell each other that one of you has seen and wishes to photograph a certain animal. Your partner may only have a moment to tell you he or she has seen a ray or turtle approaching before that animal is upon you. That moment of advance warning may be just enough for you to switch cameras, for example, and check the terrain to see where you want to take up your position.

Each photographer and model should work out their own signals. One good way to decide upon them is to review past photographs and agree upon what signal would have been preferable in that situation. Then, with a bit of practice, you will achieve the effects you are seeking.

Equipment as Prop or Pratfall

What can you do to mitigate the effects of ungainly equipment? After all, the manufacturers design it for certain functional purposes, not for sleekness or beauty, and indeed, most diving equipment could hardly be called photogenic.

The traditional black wet suit should be the first item you consider changing. If your model wears one of the new, brightly colored suits instead, you will be able to achieve real color intensity in your pictures.

Using the colorful diving suits then focuses the eyes quickly on the remaining problem of straps, hoses, and gauges. The very first series of pictures of Jessica on a Red Sea trip, for example, convinced us that we had to get rid of the tank's waist strap. When you are after a long, slim body line, the last thing you can tolerate is a brutal black waistband interrupting that effect. You can completely eliminate that strap from the camera's view. The tank is held on adequately by the shoulder straps, and the waist strap is secured with duct tape out of sight.

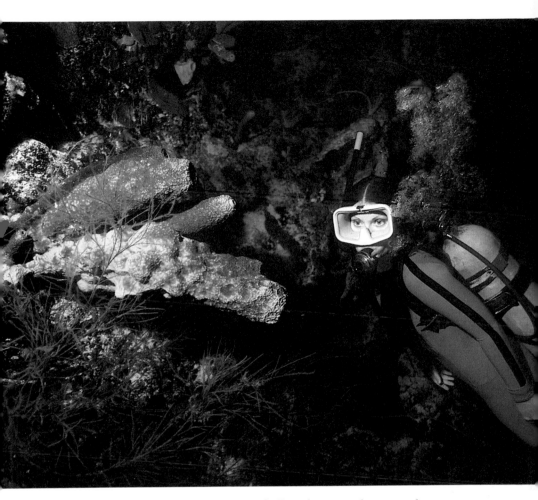

Photographs of divers are the easiest of all underwater shots, yet the most difficult to do really well (Belize, Caribbean).

Similarly, you can fold the tank pressure gauge and its ugly black hose out of sight on the side of the body that is away from the camera.

I am not suggesting that you can do nothing with diving equipment but take it out of your pictures, however. Certain equipment can very effectively be added as props. A hand-light, a camera, even a "slave" strobe light that goes off when yours does to further illuminate the scene, can add much to a picture. Still, if a picture needs a prop, I prefer it to be nature's—an animal.

The number of tricks you can learn is endless, and you will find that one improvement will logically lead to another. The reasons are quite simple: Each time you make a major improvement in your photos, some new detail will become the major irritant. One by one, you will come up with solutions to remove the sources of irritation.

The Face Behind the Mask

When using a model, you also have to deal with certain "human" problems as well. Even the most attractive eyes, for instance, look subdued and washed-out when photographed underwater. What you want, of course, is the brilliant eyes that adorn fashion magazines.

When using a female model, the answer is obvious: Use full evening eye makeup. The improvement in your pictures will be immense. For male models eye makeup is impractical, but with luck your model will have sufficiently expressive eyes.

Now, it doesn't help for the model to have spectacular eyes if you don't light them so that they show up in the picture. At certain acute angles the glass faceplate of your model's mask becomes a mirror—there you are with an otherwise terrific picture, and you discover you have a reflected coral right where your model's eyes should be.

Overcoming that phenomenon requires real coordination between you and your model. The solution involves both the angle of view of your camera and the angle from which your strobe fires. The camera must look into the mask from a point almost directly ahead to see the eyes; that is rather self-evident. However, when you photograph your model face-on, the strobe from its side-mounted position often sweeps across the model's face. The mask, projecting forward from the model's eyes, then throws a shadow across the eyes.

To avoid creating that shadow, both the camera and the strobe must manage to look into the mask. But how can you accomplish this when the camera and strobe are two to three feet apart? First, you should use a ball-joint or other arm to mount your strobe to your camera. The ball-joint enables you to swiftly move the strobe to a position closer to the camera for these shots. It will take some practice to adjust the ball-joint; but once done, it is an asset.

The second portion of this technique is to use your diving skills to move the camera rig to a position where both camera and strobe see

the model's eyes. This sounds routine, but when you and your model are in motion, perhaps being swept about by a current or surge, you can imagine that it can become quite difficult.

___ USING THE MEDIUM TO YOUR ADVANTAGE ___

When you are working in moving water, you may be able to use the tricks of experience to get your pictures. For example, I sometimes wrap my legs around a dead coral projection while Jessica lets the current carry her past the camera. Alternatively, she will hang onto the reef and I will drift by, pulling the trigger at the proper moment. For certain shots in currents, whichever one of us is not holding on may have to go hand-over-hand for quite a distance upcurrent to make another drift by. Indeed, unless the subject is stationary, one shot in moving water may be all you get.

You should be careful in these conditions to avoid dislodging debris with your hands or feet. This debris can drift into the picture and cause "snow" when lit by your strobe or drift down and frighten off your animal subject. To avoid these dangers, pick your hand- or footholds from a distance to be sure they are secure, and be careful with your swim fins. Divers moving about by means of their fins can turn clear water into sand-brown soup within minutes.

You may wonder how you can move from place to place without using your fins. As mentioned in Chapter 3, use your hands. They provide efficient propulsion as you pull yourself from handhold to handhold. If you must use your fins, move away from the reef or sandy bottom before you use your legs.

_____ DIVERS AND LARGE ANIMALS _____

As you will soon discover, photographing a diver in a stationary setting or with small animal subjects is fairly easy. You can try a shot several times until you achieve the composition and lighting you want. However, when you are trying to place your model in a scene with a ray, turtle, shark, or other large free-swimming creature, things become a bit more complicated.

Usually you will want the animal between your model and you; that's so your camera can see your model's eyes. The animal, however, may resist this, and for good reasons. These creatures live in a world

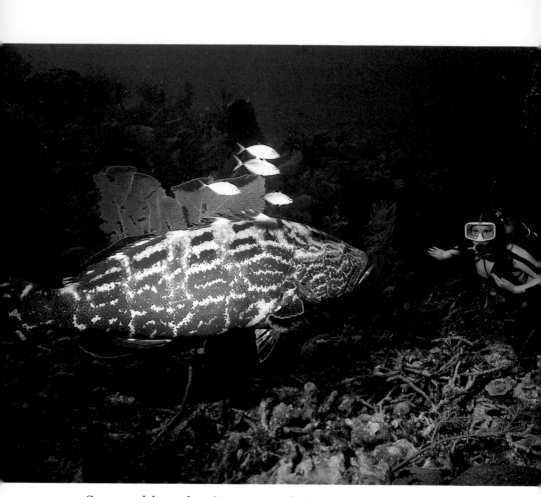

Some models, such as Jessica, are gifted at working with large animals. Here she and a huge black grouper communicated so well that the grouper also tolerated my approach (Cayman Islands, Caribbean).

in which predation balances procreation. Each animal is subject to attack by predators. To them, the friendly photographers attempting to surround them may simply be a type of big, new predator. Given this environment, most animals become agitated when they find themselves hemmed in by two or more divers. To understand their distress, imagine yourself with two big sharks moving in on you from front and rear; even if they smile, your pulse rate will escalate.

How can you tip the scales in your favor? This trick seems to work often: I will approach the animal, settle down, and even take a photo

or two. Then I remain motionless and cease breathing, trying to imitate a coral head. If the animal stays, Jessica loops around behind it from a distance. When she approaches it, she does so at an angle *as if swimming past.*

That angle of approach is quite crucial, for many animals will tolerate an oblique, but not a direct, approach. Indeed, if it works once, she will often swim right past, angle away, and return for another pass.

If the animal subject is feeding or being cleaned of parasites, it may be reluctant to leave its position. These are both excellent situations for the photographer but still require patience and caution to exploit.

Often the best pictures are those in which model and animal react to each other on camera. A good example of this is the photograph on page 26, taken on a remote reef in the Philippines. Here, we encountered three cuttlefish, two of which were laying their eggs amid the coral. One of these engaging creatures swam along with us curiously and even exchanged gentle touches with Jessica. You will find that many of your greatest thrills in the sea come from such personal encounters.

Should you carry food to attract animals? Some divers swear by this technique and won't enter the water without a bag of raw fish or even bread. Under some conditions, bringing food can work quite well. When you are trying to bait sharks, for example, raw fish and especially freshly speared fish may be the only effective baits. In a reef situation, though, fish bait may attract precisely the wrong animal (an aggressive grouper or moray, for example) which will frighten off the animal you hoped to photograph.

As a general rule, I do not use bait except to photograph certain larger predators. (More on techniques of photographing smaller fish in the next chapter.) That is because of the unpredictability of the outcome. I mentioned attracting the wrong predator and particularly, when working with a model, you do not wish to court trouble. Models can be nipped by moray eels, stung by lion-fish, stripped of an entire bag of bait by a huge grouper or Napoleon wrasse. Baiting adds another variable, the element of uncertainty, which may well work against your getting the picture you want. With no bait in the water

you may have to be a bit more skillful to approach the subject, but there won't be those sudden surprises from out of the blue to upset your careful plan.

Over the years I have found that big groupers are often quite curious but are sometimes more comfortable if I avoid direct eye contact. These fish have come in to look over my shoulder as I took pictures, only to race away when I turned and looked directly at them. Others, as you can see from the photo at the bottom of page 27, are so sassy you can practically touch them. Experience may eventually help you to quickly differentiate between shy and bold individuals, but the best course is to be cautious and unobtrusive until the animal convinces you it will stay.

Turtles will sometimes approach a single motionless diver, I suspect misidentifying the human as another turtle. I have had this happen with large turtles in Australia (see page 58), New Guinea, and the Galápagos islands. Indeed, in two of these cases the turtles were so determined to discover another turtle that they returned to me several times. I find that holding my breath helps in this modest deception. Naturally the same turtle is *not* fooled when two or more divers are moving about, exhaling noisy bubbles. Young turtles, though, are sometimes quite tolerant of even multiple divers as long as they are slow and quiet.

Rays are usually shy, and only on a few occasions have small rays tolerated a human's approach. More often they soar away, maintaining a huge margin of safety. There have been numerous instances, however, of very large rays or whale sharks being ridden by divers.

One last point to remember: Modeling with some of these larger animals can involve large doses of luck as well as technique. All the technique in the world won't get you ideal pictures with a whale shark if the animal doesn't show up.

IT TAKES TWO

What is perhaps most evident from the foregoing discussion is that photography with models is a joint venture. It can be very difficult when photographer and model are working together for the first time, before communication has been developed. If you can, it's preferable

to work with the same model many times; if you can't, be prepared for some inevitable frustration when you look at your results. It is neither your fault nor your model's; it's just that you haven't worked out the details of a necessary partnership. I have seen the best photographers frustrated by new or incompetent models and vice versa. In fact, both model and photographer must operate at a high level of skill to achieve any degree of proficiency. Anyone can be lucky in a single shot, but a long-term success takes both luck and skill, with lots of coordination between model and photographer a vital ingredient.

Spend time going over the results with your model. Try to re-create what you were thinking in the water, what signals you used. Did you misunderstand each other? Did you "work" your animal subject successfully? Did you achieve any interaction with the animal?

Don't let your ego get in the way. Models regularly make crucial suggestions; factor those insights into your plans for future dives. Remember, your model may be swimming along hoping you will be skilled enough to take the picture he or she has created.

THE IDEAL MODEL

What should you hope for in a model? Brains, diving skill, an ability to work with animals without fear, sharp eyes, personal style, and expressive movements.

Next time you look at an undersea picture that features a model, critique the picture: Are any straps dangling? Equipment intrusive and clumsy? Model in an awkward position? Does the presence of the model cause the picture to express the photographer's idea more completely? Is the animal or reef or sunburst more beautiful because of the model's presence? This is not only good practice in developing your own eye for details but will show you just how important a good model is to the final success or failure of a photograph.

After you have worked with a model for a while, you will find yourself looking at certain scenes and mentally inserting that diver to complete the picture as you would like it. If your model is nearby, you will quickly signal him or her to the scene. If that person is not with you, the scene will seem frustratingly incomplete.

EIGHT

FISH PORTRAITURE:
THE ULTIMATE SKILL

Over the years I have met a lot of fish, and to paraphrase Will Rogers, I have never met a fish I didn't like.

As I have mentioned earlier, most fish live in constant danger of predation. Given that environment, take a look at the front of the camera and imagine what it resembles from a fish's point of view. *A large, approaching, open mouth.* That's right, and I suspect it is one part of the puzzle called "Why don't the fish let me come closer?"

BACK TO BASICS

Your camera looking like a mouth is only one part of the puzzle, though. Early in this book I described the diver thundering awkwardly down from the surface to land amid the reef scene like a bomb. Remember? It led to a discussion of swimming, diving, and stalking skills. That discussion was the heart of all fish photography. To put it another way, *in a world of sudden predation, try not to look like an oncoming predator.*

The most often-asked question I hear is: "How can I get those close-up portraits like yours?" There is no simple answer, for I have spent years refining those techniques. Still, the fundamental answer is: Learn to be a better, less intrusive diver. It is a matter of opinion,

frankly, whether being a superb stalker is seventy, eighty, or ninety percent of fish portraiture. One thing is certain, however. If you scare off your subject you have a *zero* percent chance of getting its picture.

Without repeating all the hints in Chapter 3, rereading it will give you at least half of the techniques you would expect to find in this chapter.

THE FISH'S EYE

Perhaps the best trick of all is to keep imagining things from the fish's point of view. After all, if you do get close enough to take a real portrait, the glass of your lens will be only a few inches from that fish's face. The fish is small; you are, by comparison, immense. If you were its size, how would you react to a camera-toting monster bearing down on you? For this reason your approach is crucial; it totally overshadows other factors such as what kind of camera, strobe, or diving equipment you use.

How can you get close enough to a fish to get its portrait? To begin, the less of you it sees and hears, the better. In Chapter 3, I spoke of

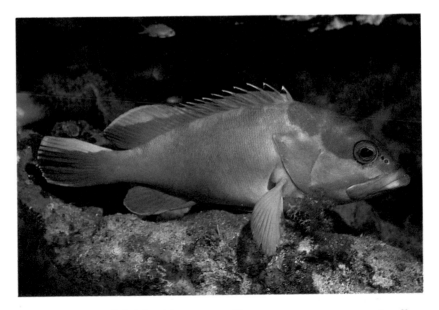

Getting a wary fish like this grouper, Epinephelus fasciata, *to allow you this close is the acid test of all your techniques (Red Sea).*

low, slow, and quiet approaches. That means, when you spot a really good subject, you should instinctively begin a specific thought process. Without taking your eyes off the subject, you should be assessing any cover the reef may offer: Is there a coral head or sponge or fan the fish may approach that you could hide behind? Any tunnels or caves to hide in? Can you anticipate the fish's route? Is it moving swiftly or slowly? Is it stopping off now and then to feed? Is it alone, or in a pair, or even a group? Are there any features in the terrain that might force it closer to you? Is there anyone else in the area who may frighten it off? Could someone else cause it to come to you? What can you do to get really close to it? What f-stop will you use? What strobe angle and power setting? What body angle are you hoping to get? Do you wish to isolate this fish, or photograph it against some particular background? Is its body color and texture reflective or absorptive? There may be a thousand other questions, but you get the idea.

As I say, you should be asking and answering all of these questions routinely *before you ever begin your approach*. Why? Because if you commit yourself and you have missed one of these critical decisions, the whole exercise is a waste. You won't get the picture you want if you fail in any detail.

But, you say, by the time I finish all that the fish will be gone anyway. Perhaps, but unless the fish is of a rarely seen species, there'll be another one along later. In the meantime, you won't have wasted the film, and you'll have it for the next opportunity.

PACE YOURSELF

There's an unwritten law in underwater photography to the effect that the best subjects always come after you have run out of film. That "law" arose purely out of the unfortunate tendency of most divers to be gunslingers with their cameras. During the first fifteen minutes of a dive the reef is often ablaze with strobe lights. Then there is a long, hushed pause, and you can see the shark or ray or turtle smiling at the empty cameras as it finally approaches.

I have had divers come to me and swear that a fish eluded them time and again until they ran out of film, then danced right in front of the camera. What these divers never consider is that their own

behavior is different after they run out of film than while shooting.

While they have film in their cameras, they are probably swooping around the reef like fighter pilots with strobe lights blazing. Fish dive for cover; morays cower in their holes. Sharks, turtles, and rays head for open water. There is a palpable tension, almost a violence, abroad on the reef.

Once these divers run out of film, they relax. They settle down in one spot and even breathe more slowly. A sense of quietude, of danger past, is felt on the reef. It is Dodge City after the shootout. Morays poke their heads out of holes; fish resume their feeding; reef life returns to normal.

So let's take it from the top. You begin by developing your swimming and diving skills. That makes you *able* to stalk a wary fish if you decide to. It also makes you less of a disruption on the reef, enabling the animals to pursue their normal routine in your presence.

THE UNDISTURBED REEF

Sometime just try holding onto a dead coral head and remaining totally still for five minutes, breathing slowly and gently. The reef will become quite active and normal about you. That is what you are trying to achieve. Besides, when you are absolutely still, you're not damaging anything on the reef. Now, when you begin to move, watch things disappear or move out of your way.

With practice and concentration, you can almost achieve as little disruption when you move as when you are still. You move on your fingertips, and slowly. If you do let your legs settle behind you, let only the tips of your swim fins gently touch the coral.

If you are going to work in one small area, pick a dead coral and squeeze it between your knees. That makes your whole body a sensitive tripod for your camera and eye.

When you are done with one area, use your buoyancy to rise gently, then move hand-over-hand, scanning ahead with your eyes. Every movement should be fluid, gentle. If you are exerting, you are releasing clouds of noisy bubbles. Breathe slowly and shallowly. That's it. More and more you are becoming like a silent, stealthy predator.

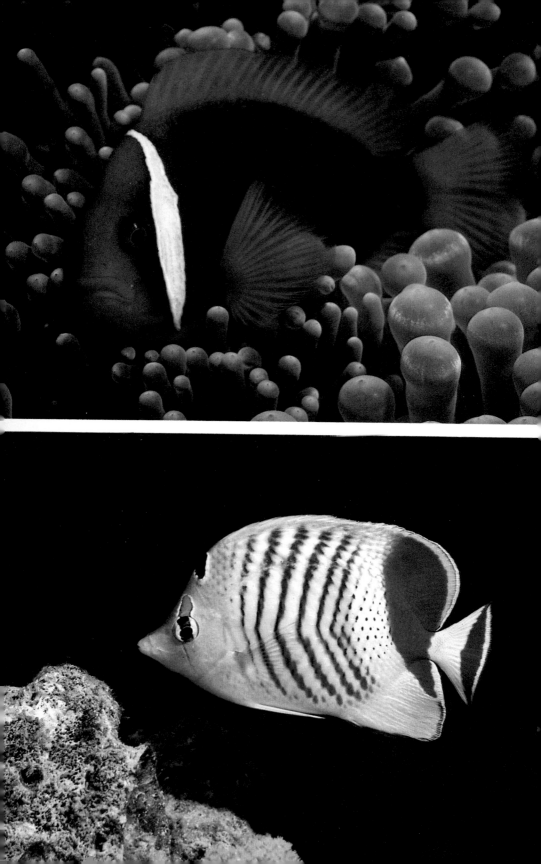

PUTTING IT ALL TOGETHER

Now go back to those earlier rapid-fire questions from page 80. You'll see that they actually organize themselves into several major topics:

Evaluation of the terrain.
Its influence on the intended photograph.
The mental state of the intended subject.
The technical settings of camera and strobe.
Special lighting and composition elements.
Outside influences that could help or hinder you.

Let's take these in order and see where they lead.

The interplay of fish and background is a supreme challenge (top left: *tomato clown fish, Philippines*; bottom left: *orange-tailed butterfly fish, Red Sea*; below: *clingfish, Coral Sea, Australia*).

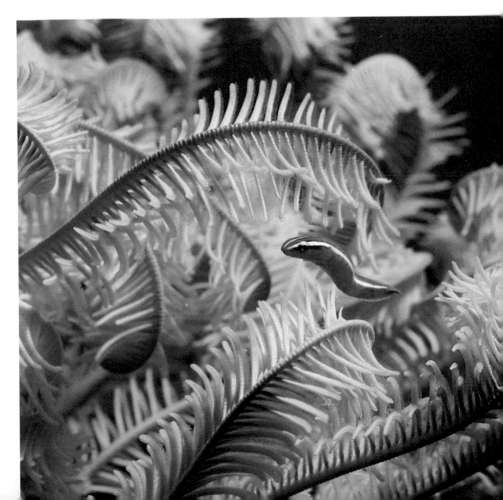

Evaluating the Terrain

There are several scales of terrain that range from macro terrain (the entire reef) to micro terrain (the coral head or crevice the subject is using for cover).

Macro terrain considerations might include:

1. Can I use the edge of the drop-off to shield myself from the fish's view?
2. Should I swim around the large coral mass to approach the fish from another angle?

Micro terrain considerations would include:

1. Can I get strobe light into that tiny crevice?
2. Is the fish in a cul-de-sac so that I can use my hand to try to "influence" it to a better body position?

And between those two extremes are such questions as:

1. If that fish swims along this coral head as it is doing, can I use the coral's curvature to bring the fish closer to me?
2. Where is this fish heading, and can I unobtrusively get there first?

I chose these specific questions to illustrate how very critical terrain can be to your success in fish photography. It is the fish's home ground, after all, and that animal is going to use it to keep itself safe at all times. To get closer than it wants you to be, you have to become more clever in using the terrain than the fish is.

Using the Terrain

Reef topography cuts both ways. Crevices often lead to openings, and many of my fish portraits consist of not only beating the fish to the opening but surprising it by doing so. After all, if the fish knows I have gotten there first, it won't come out. That means I have to get there, set up, become motionless, and hold my breath. Often my quarry comes sailing out of its shelter and never registers my presence until the strobe goes off.

There is a good reason that all of this works. Fish have *ranges*, particular territories they traverse day after day. In doing so, they

identify "safe routes" to which they retreat when predators are near. Most predators such as sharks or barracuda can be avoided by merely ducking under or into the simplest shelter, so that's all the fish uses. Since the predator usually gives up as soon as the fish reaches its shelter, there is no reason for complex or arduous routes; a few "safe holes" and overhangs are all the fish ever needs.

If you dive the same reefs frequently, you will begin to see the same fish use the same escape routes again and again. Soon you can anticipate their probable routes and intercept them.

Using the terrain is a major skill that takes time and practice to develop. But as you can see, it is time well spent.

The Subject's State of Mind

This terminology might seem a bit grandiose, but I believe it is apt. Just as the diver brings certain mental states to this contest, a fish has its own mental outlook. Presumably it is simpler than ours, but consider these possible scenarios:

1. The fish's mate was devoured yesterday by a grouper that struck like lightning from beneath a shadowed overhang.
2. This morning a lizardfish arrowed up off the sand and actually got a bit of this fish's tail in its mouth before the fish wrenched free and escaped. The tail still stings from the minor wound.
3. Three minutes before you approached, your dive buddy's swim fin knocked over the small coral head under which this fish usually sleeps. The crash terrified the fish.

And now, here you come. . . .

Going Beyond Technical Settings of Camera and Strobe

Exposure settings and light output values are the principal meat of every underwater photography course. In fact, exposure values and distances are printed on many strobe lights currently on the market.

It's easy to read off the strobe that at, say, a two-foot distance the proper f-stop is f-11. What if the fish swoops to within eighteen inches, or is so large you have to be three feet away to fit its image into your field of view?

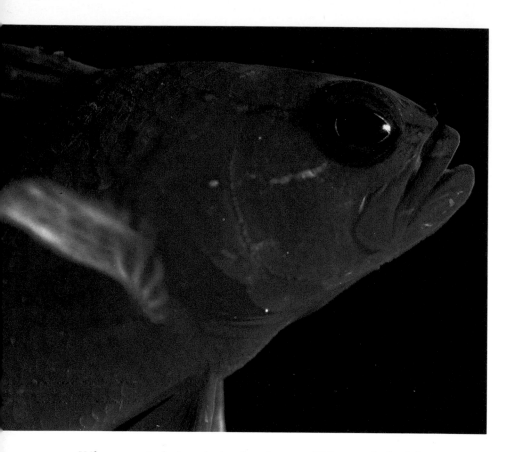

When your technique is developed, you will "express" the fish on film (above: macrophoto of a royal gramma, Curaçao, Caribbean; top right: *spine-cheeked anemone fish, Papua New Guinea;* bottom right: *king angel fish, Red Sea).*

The real trick is to properly execute all you have been taught during those complex, tense moments when the adrenaline is flowing and you're trying to think of everything at once. Is it hard to concentrate under these conditions? Of course. It's the same type of concentration a race-car driver or an acrobat must develop. Different photographers master this to different degrees.

Talking with editors who review the photographs submitted to diving magazines, I have been told that the club of master fish photographers is the smallest and most exclusive club of all.

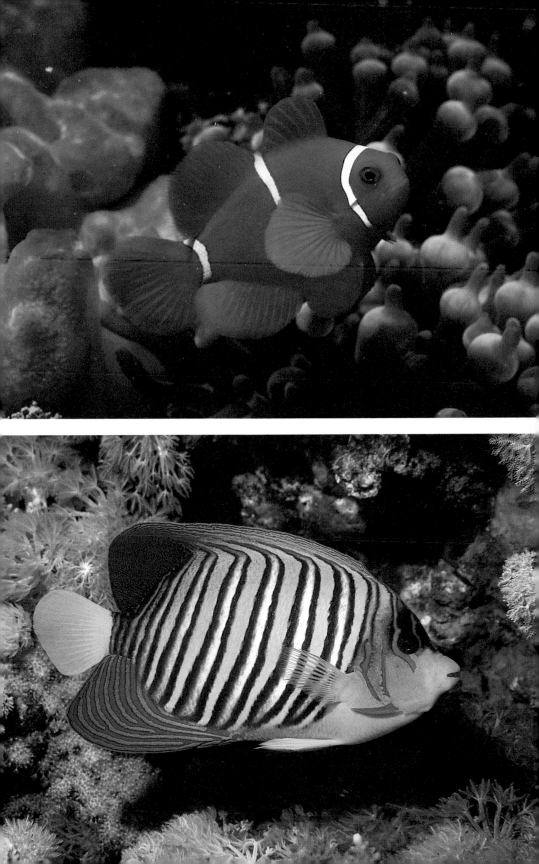

Let me be precise about that title "Master Fish Photographer." I mean the diver who, in *any* terrain at *any* time, consistently brings back magazine-quality portraits of free-swimming fish. Any diver will occasionally get a great shot. As you become more skilled, you will get an increasing percentage of marketable shots. When the book publishers and magazines call you for photographs and you begin making your living taking marine portraits, you are achieving the level I have in mind.

Wait a minute, you're saying. I don't want to make my living taking fish pictures. I just want to get some of those good shots I see in the magazines. Unfortunately, to get those shots at all requires some of the same single-minded determination master fish photographers bring to their work. You can't expect to get those results until you have spent many dives and many rolls of film developing your skill. I've seen some divers be very hard on themselves because they don't get publication-quality photographs right off. Don't let yourself be caught in that discouraging trap. Just work at it, look at your results, try to analyze your errors to avoid them on future dives.

Special Lighting and Composition Elements

While I personally shoot what are called documentary, or real-life, portraits of marine life, many photographers seek special effects by tricks of lighting or artistic composition. For that matter, even a documentary portrait is enhanced by artful composition.

Any number of techniques have evolved; indeed, the techniques are as numerous as the photographers, so I will mention just a few common ones.

Back-lighting involves bringing your strobe light at your subject from behind. These photos are characterized by a "halo" of light around the subject and can be very effective.

One problem with back-lighting is that it may leave the front of the subject dark. Some photographers relieve that by back-lighting with a powerful strobe, then front-lighting with a smaller strobe.

A second caution with back-lighting is not to get the flare of the strobe into the picture: It's so bright that it will "burn out" the film with an intense light flare. Be sure that you cannot see the face of the

strobe itself in your composition, and you'll avoid this hazard.

While stationary subjects allow these tricks, fish often will not. After all, you are surrounding the animal with metal and plastic much like the jaws of a trap. Would *you* stay there?

Multi-strobe lighting is used for filling in the harsh shadows a single strobe may throw on a subject or putting more light on any subject to achieve a higher f-stop. Partisans of this technique swear by it; I personally view the minor picture improvement not worth the weight, exertion, and inconvenience of carrying an extra strobe and prefer simplification.

Even further out is *area lighting,* in which the photographer anchors several strobes in an area and sets them all off at once using light sensors, or "slave strobes," to fire all the strobes together. Again, except for certain unusual shots or shooting conditions, I urge you to use the simplest rig that will do the job. (In lighting conditions where you don't need strobe lights for color and stop-action, I suggest you get rid of those, too.)

Just remember that every piece of gear you carry will sooner or later flood or break down. The more complex your equipment, the more likely it is that something will break or leak and abort your dive. By the same token, simplicity of technique and overall skill are more likely to yield a good photo than overly lavish effects. I tend to leave special effects to Hollywood. Remember that your purpose in underwater photography is to bring home a decent percentage of good pictures. The more you experiment, the more you risk.

Intruders Which May Affect Your Plans

The coral reef is a multifaceted environment. In any given area, even a barren-looking scene, there are all kinds of unseen animals about. When you are moving in on an animal for a portrait, then, don't be surprised if something else intrudes.

Many of my portraits of larger animals came precisely from their intrusion into some completely different scene. I remember stalking a butterfly fish years ago on a reef in Australia. Suddenly, as I closed

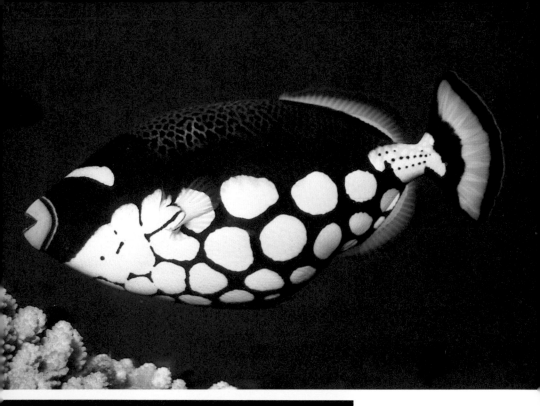

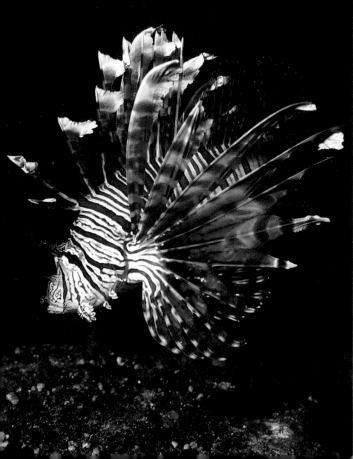

Sometimes an
expressive fish portrait
requires a long period
of tense immobility on
my part, but the
result is surely worth
it (above: *clown
triggerfish, Coral Sea,
Australia*; bottom left:
lionfish, Philippines).

in on it, I had a nagging feeling that something on this reef was out of place. This thought so disturbed my concentration that I lifted my head from the eyepiece and cautiously looked about.

Everything was fine, except for a hovering coral head right next to me. Hovering coral head? I looked more closely and discovered that the hovering coral was staring at me with a vivid eye. It wasn't coral at all, but one of those extraordinary creatures called a cuttlefish. This master of disguise was trying to remain unseen by imitating coral—spectacularly well, I might add. Instantly gone was any thought of the butterfly fish, and for the rest of the dive I reveled in the magic of the unusual cephalopod as it constantly changed its color and texture.

Similar intrusions of rare or unique subjects into routine scenes have given me memorable portraits of manta rays, whale sharks, huge turtles, sharks, porpoises, and other animals.

———— WHAT DEFINES A FISH PORTRAIT? ————

What are we really looking for when we attempt a portrait of a fish? Clearly, the evocation of an ephemeral moment: the turn of its body; its eye upon us; perhaps its body framed in brilliant coral. In a way, we want more than its picture. We are really trying to capture the incandescent idea of *that* creature in *that* special moment.

When someone else sees the portrait, they don't realize what magic communion you the photographer shared with the fish in that moment; it's just a fish on the page of a book. If, however, you can capture that evanescent idea or personality of the animal, it will communicate itself to the reader.

In the end, that is the difference between a fine portrait and the hundreds of ho-hums you may have seen. Invariably, the mediocre photos involve a fundamental error: The photographer may well have reveled in the magical moments he or she shared with the reef creatures, but the photographs missed the magic.

Your next question will surely be, "Okay, I see what you mean, but how *do* you capture those moments?"

Unfortunately, the answer lies in your communication with the fish, your perception of its mood, your anticipation of its moves. After many years of observing them I "read" fish pretty well. I suppose it

is like someone who spends years with horses or dogs or falcons or even snakes.

That, finally, is why fish portraiture is the ultimate undersea skill. It is a blend of technical competence with camera and lighting, a stalker's stealth and ability to read the terrain, and finally that elusive communion with the quarry.

When you have crossed the open reef, gotten close to the fish, and finally maneuvered your massive camera mere inches from its face, your heart soars when you pull the trigger. You know in that instant that you have woven all the critical talents together to capture that special personality of the fish.

NINE

SUMMING UP:
YOUR GOALS AND HOW TO REACH THEM

We have come a long way together. From the early consideration of what equipment to use, we've evolved into lighting, a spectrum of possible undersea subjects, and the special techniques you will weigh in developing your own style.

I made that point earlier, but it bears repeating. Every photographer must pursue his or her own special style. I have offered you a number of elements I consider in producing pictures in my style. You, however, must pick and choose from among various techniques to suit your own "photographer's eye." There is an infinite variety of subjects and a limitless range of treatments for each of them.

When a top underwater photographer puts together a book or a show, you will find that he or she includes wide-angle reef scenes; shots with models; big, dramatic animals; and portraits of invertebrates and fish. Not only will the subjects vary; a properly coordinated selection will also evoke the infinite contrasts of diving locales all over the world. After all, subjects in Australia or the Red Sea are totally different from those in the Bahamas or the Caribbean.

As you approach each of the main categories of photography, you will find you want to achieve certain effects to convey the subject as *you* saw it. For example, some divers like to shoot reef scenes in the

late afternoon when visible sun rays fill the water; others prefer high noon for maximum light penetration plus a "clear-water" look.

Some photographers prefer a fish always in a frame of corals, the creature in its natural environment. They visualize the fish as a part of a scene, and their photographs blend fish photography with stationary-subject photography (see, for example, the photograph below). At the other end of the spectrum, many of my fish portraits are isolationist; they try to bring the fish *out* of the background and fill the world with it. How you look at your subject is merely a matter of what your own eye sees as the finest evocation of that animal.

Underwater photography, in the end, is the most intensely personal of artistic sporting endeavors. In few human activities are you as alone in a foreign element, in few do your own skills and adaptation so completely define your success. When your results are up on a screen or on a magazine page, they are the embodiment of both your perception and your prowess. The audience reaction is certainly a part of your reward, but they weren't with you when you squeezed the trigger. That moment is all yours.

After a time you will find your own way, the picture that expresses that fish as *you* see it. When you begin getting those portraits, you'll have that special personal thrill, too. Your audience may never realize how seamlessly you've woven the requisite skills to get that perfect picture. But *you* will.

You can "frame" a fish in coral (Coral Sea, Australia).

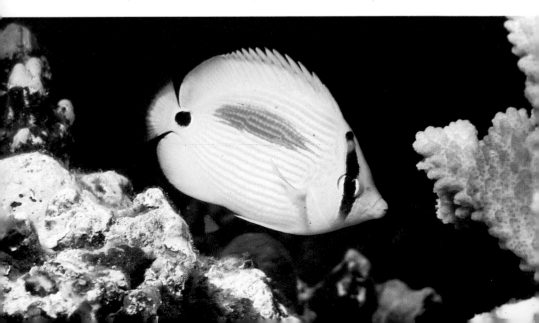

COMMON QUESTIONS ABOUT TECHNIQUE

Over the years I've been asked certain questions again and again. Here are some solutions or answers that have worked for me. I offer them here in hopes they lead to an answer for you.

1. **How can I take portraits like the ones I see in magazines?**
 Basically, improve your diving and stalking skills (Chapter 3). Until you have those, you can't get close enough to the wary subjects.
2. **What lens do you use for those portraits?**
 For fish portraits I use a motorized Nikon F camera with a 55mm Auto-Micro-Nikkor lens, all in a ten-year-old housing. For larger subjects I use a Nikonos with a 15mm lens, and also a motorized Nikon F with a 24mm lens. The lenses are still standard, though newer Nikon and Canon cameras are available. Motorized cameras are handy in certain situations where it would be awkward or too slow to manually advance, for example, in close quarters with fidgety fish or in fast-developing shark scenes. You can do quite well without them in most photography. Oh, and yes, it's a pain in the neck to carry it all.

3. **What film do you use?**

 Kodachrome 64. I like its color balance and saturation; in addition, over the years Kodachrome has a big advantage in shelf life —my old Ektachromes have long since faded.

4. **Is a housed camera better than a Nikonos-type camera?**

 For portraits of fish I believe it is. That's because you are looking for a precise pose and composition, and through-the-lens close-up viewing is the only way to achieve it. For stationary subjects or large subjects, a framer or a wide-angle lens on a Nikonos will do equally well.

5. **In my wide-angle shots my subject is too small. What am I doing wrong?**

 Wide-angle lenses require that you move in close to the subject. The hardest part of learning to use these lenses is that the proper distance to work in is closer than you believe at first. Keep moving in and watch your results improve. See page 17, "Lenses for Larger Subjects."

6. **How do you aim your strobe accurately?**

 Hold it in front of you or even lay it on the reef and look at it from the subject's point of view. You'll see immediately if the strobe is aimed properly. See page 32 for further information.

7. **A lot of my pictures are too dark. Is there something wrong with my strobe?**

 Strobe light rapidly diffuses in the water. Unless you bore in close to the subject, you'll notice a consistent pattern of underexposure. Many beginning underwater photographers simply don't get close enough to their subjects to properly light them. A second alternative is that your strobe is underpowered for the distances with which you are working. Check the manufacturer's recommended distances and exposures.

8. **I'm using a wide-angle lens and find that my strobe doesn't cover the entire field of view. What can I do?**

 When you are using superwide lenses of 15mm or so, only a few strobes can cover such a wide field of view. However, many wide-angle pictures are of animals and models surrounded by blue water, where the corners of the picture are not really important. In any event, the proper aim of your strobe in these cases is

critical. See Chapter 4, "The Role of Light," particularly pages 37–9, "Wide-Angle Lighting."

9. **How do you get the strobe light into small crevices where the animals are?**

 This may require moving the strobe closer to the camera so that they share the same view. Or, you may rotate the camera until lens and strobe are aligned in the plane of the crevice.

10. **When I take fish pictures from very close up, sometimes the fish is dark, even when the background is lit. Why is that?**

 This may involve either light-absorptive skin on the fish or conceivably a shadow from something blocking your strobe. When your strobe is pointing downward on a vertical fish, it's even possible for the fish's own dorsal fin to cast a shadow on its body. See "Close-up Photography," pages 33–6, for a discussion.

11. **How do you get those black backgrounds in your fish pictures?**

 By getting really close to the subject and using a higher f-stop. This shuts out the ambient light completely, leaving the background black.

12. **Last time I took some underwater pictures I found light speckles in the blue water. What causes that?**

 That's backscattering, which is discussed in Chapters 1, 3, and 4. It may be plankton occurring naturally in the water, or sand you or someone else kicked up. You can sidelight it (Chapter 1) to minimize its impact on your shot.

13. **All I ever see is the departing tails of big animals. How do I get in front of them?**

 Partly luck, of course. One way is to have a partner serve as spotter. Mostly, whatever you are doing, be sure you look all about you every few seconds. I've seen many a manta ray or turtle approaching this way. For further advice see pages 53–4, "Preparing for Confrontation."

14. **How do you get the fish in an attractive position for its portrait?**

 That takes a book by itself (or at least Chapter 8 of this one), but it basically requires squeezing the trigger at the proper moment. Most fish subjects continually go in and out of attractive poses; you must track their movements so you can pick your time to shoot. Hand-eye coordination is usually the answer.

15. **How do you get a fish in focus? It keeps moving in and out on me.**

 Same answer as number 14. It's almost like a video game, when you think of it. Unless the fish flees, it'll give you several opportunities if you can just see the scene shaping up and manipulate your controls skillfully.

16. **I can't get those fish to stand still, so how can I get their picture?**

 Keep in mind that in the contest between you and the fish, you're playing the game in their medium, so you must develop a higher level of skill to win. You might review "Putting It All Together," pages 83–92.

17. **My model pictures don't look nearly as good as yours. What am I doing wrong?**

 Remember, my model, Jessica, and I have worked many years for those effects. The answer to this one may be a lot of shooting and reviewing to make improvements in your communication.

18. **When I take model pictures it's often completely black inside my model's mask, and I can't see the eyes. How can I correct that?**

 See the discussion in the chapter on model photography (Chapter 7). In addition, you may have to alert your model to the proper placement of his or her head. If your diver/model is constantly looking under ledges it may be hard to light the eyes.

19. **How do you organize your photo collection?**

 Usually by geographic area. Within any area I have three quality levels to optimize my search time.

20. **How do you physically store your slides?**

 In twenty-slide vis-sheets. As long as the collection is active and in a moderate temperature, you should have no damage from contact with the plastic. Other alternatives are to store them in slide trays ready for viewing, or even in the boxes in which they are returned from the lab.

INDEX

References to illustrations are in **boldface**.